*Remembering Shakespeare*

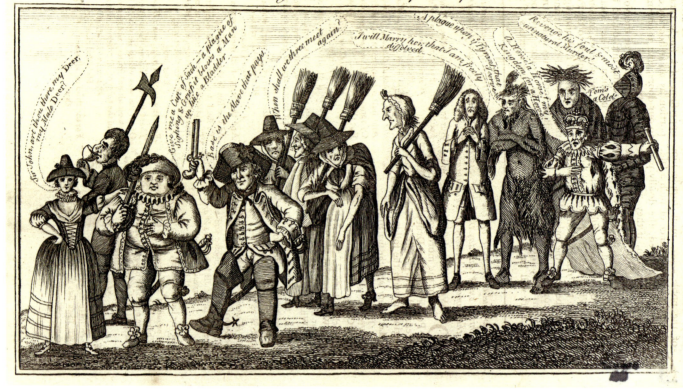

*Procession at the Jubilee at Stratford upon Avon* [London, 1769]. The Lewis Walpole Library, Yale University

# *Remembering Shakespeare*

David Scott Kastan and Kathryn James

Beinecke Rare Book & Manuscript Library, Yale University
Distributed by Yale University Press, New Haven and London

Copyright © 2012 by Yale University. All rights reserved.

This book may not be reproduced, in whole or in part, including illustrations, in any form (beyond that copying permitted by Sections 107 and 108 of the U.S. Copyright Law and except by reviewers for the public press), without written permission from the publishers.

Published by Beinecke Rare Book & Manuscript Library, P.O. Box 208240, New Haven, Connecticut 06520-8240
www.library.yale.edu/beinecke

Distributed by Yale University Press, P.O. Box 209040, New Haven, Connecticut 06520-9040
www.yalebooks.com/art

Library of Congress Control Number: 2011944657
ISBN 978-0-300-18039-8

Cover illustrations: Shakespeare's name and printer's ornaments from works in Yale University collections

# Contents

*Acknowledgments*  7

*Introduction*  9

I  *The Beginnings to 1616*  11

II  *Shakespeare Invented*  25

III  *Shakespeare Monumentalized*  31

IV  *Shakespeare Improved*  41

V  *Shakespeare Restored*  47

VI  *Shakespeare Deified, Forged, Denied*  51

VII  *Shakespeare Disseminated*  57

VIII  *Shakespeare Modernized*  69

*Afterword: Shakespeare at Yale*  73

*Selected Bibliography*  77

# BRUSH UP YOUR SHAKESPEARE

Saint Subber & Lemuel Ayers present

## KISS ME, KATE

*A Musical Comedy*

Music & Lyrics by
**COLE PORTER**

Book by
SAM & BELLA SPEWACK
Choreography by
HANYA HOLM
Settings & Costumes designed by
LEMUEL AYERS
Production Staged by
JOHN C. WILSON

Also Published Separately from the Score:
WUNDERBAR
SO IN LOVE
WHY CAN'T YOU BEHAVE
WERE THINE THAT SPECIAL FACE
BIANCA
ALWAYS TRUE TO YOU IN MY FASHION
I HATE MEN
I AM ASHAMED THAT WOMEN ARE SO SIMPLE
TOO DARN HOT
I SING OF LOVE
WHERE IS THE LIFE THAT LATE I LED?
TOM, DICK OR HARRY
WE OPEN IN VENICE
ANOTHER OP'NIN', ANOTHER SHOW

$1.50

Theodore Presser Company
Bryn Mawr, Pa 19010
for
chappell music company — A POLYGRAM COMPANY
Printed under special license by Theodore Presser Co.

# Acknowledgments

This exhibition and catalogue draw on the extraordinary collections of works by or relating to Shakespeare held by Yale University's Elizabethan Club, Irving S. Gilmore Music Library, Lewis Walpole Library, Yale Center for British Art, and Beinecke Rare Book and Manuscript Library. We would like to acknowledge the generosity of these repositories in loaning from their collections to this exhibition and allowing the reproduction of these works in this catalogue. We would particularly like to thank Roberta Frank, Suzanne Lovejoy, Lawrence Manley, Amy Meyers, Stephen Parks, Margaret Powell, and Scott Wilcox.

Exhibitions depend on the expertise and energies of all those around them. We would like to express our gratitude to Aaron Pratt and Matt Hunter, research assistants; to Thomas Fulton and Jessica Brantley, who read early drafts of the text; to Christa Sammons, for her talents as editor and proofreader; to Doreen Powers, for her generous assistance in coordinating the project; to Rebecca Martz, for her insight and imagination as the designer of the catalogue; to John Gambell, University Printer, for his generous eye for details and design; to the staff of the Beinecke Rare Book and Manuscript Library, and in particular the digital metadata and digital studio staff; and, for his remarkable enthusiasm and support for this project, E.C. Schroeder, Director of the Beinecke Library.

Any exhibition is, of course, itself a virtual collaboration with the many scholars who have worked on the materials over time. It would have been impossible even to imagine this exhibition without this long history of scholarship, and we hope this catalogue, as the exhibition itself, will serve, however inadequately, both to indicate our great indebtedness to this scholarly tradition and even greater respect for it. Finally, but most significantly, we would like to thank our respective families for allowing us the time to put this together, showing remarkable patience and even, most of the time, genuine interest. This catalogue is dedicated to Julian, and to JEK, AL, and MK.

1
Cole Porter, *Brush Up Your Shakespeare* (New York, 1949). Beinecke Library, Yale University

# A CATALOGVE

of the seuerall Comedies, Histories, and Tragedies contained in this Volume.

## COMEDIES.

| | |
|---|---:|
| The Tempest. | Folio 1. |
| The two Gentlemen of Verona. | 20 |
| The Merry Wiues of Windsor. | 38 |
| Measure for Measure. | 61 |
| The Comedy of Errours. | 85 |
| Much adoo about Nothing. | 101 |
| Loues Labour lost. | 122 |
| Midsommer Nights Dreame. | 145 |
| The Merchant of Venice. | 163 |
| As you Like it. | 185 |
| The Taming of the Shrew. | 208 |
| All is well, that Ends well. | 230 |
| Twelfe-Night, or what you will. | 255 |
| The Winters Tale. | 304 |

## HISTORIES.

| | |
|---|---:|
| The Life and Death of King John. | Fol. 1. |
| The Life & death of Richard the second. | 23 |
| The First part of King Henry the fourth. | 46 |
| The Second part of K. Henry the fourth. | 74 |
| The Life of King Henry the Fift. | 69 |
| The First part of King Henry the Sixt. | 96 |
| The Second part of King Hen. the Sixt. | 120 |
| The Third part of King Henry the Sixt. | 147 |
| The Life & Death of Richard the Third. | 173 |
| The Life of King Henry the Eight. | 205 |

## TRAGEDIES.

| | |
|---|---:|
| The Tragedy of Coriolanus. | Fol. 1. |
| Titus Andronicus. | 31 |
| Romeo and Juliet. | 53 |
| Timon of Athens. | 80 |
| The Life and death of Julius Cæsar. | 109 |
| The Tragedy of Macbeth. | 131 |
| The Tragedy of Hamlet. | 152 |
| King Lear. | 283 |
| Othello, the Moore of Venice. | 310 |
| Anthony and Cleopater. | 346 |
| Cymbeline King of Britaine. | 369 |

# *Introduction*

It is a truism that Shakespeare has been remembered. Unquestionably he is, as Harold Bloom has said, "the most memorable of writers." All of us can quote snatches of plays or poems that we read in high school or saw in the theater: "To be or not to be," "My kingdom for a horse," or "Shall I compare thee to a summer's day." The truism, however, hides a more interesting and more fundamental truth: not only that Shakespeare has been remembered over time in a way that none of his contemporaries has been, but also that Shakespeare in fact exists for us only through various interested acts of memory that have not just preserved but constructed the texts, even the person, that we think of as "Shakespeare." Drawn from the extraordinary resources at Yale, most of the items in this exhibition have never before been on public display. They are brought together here to chart the process of remembering that has allowed Shakespeare to be transformed from one of a number of talented writers for an emerging entertainment industry in Elizabethan England into the best-known and most highly valued author in the history of the world.

From the beginning he was remembered. Actors remembered their lines in order to perform on stage, and sometimes remembered (or misremembered) them afterwards to construct a version of the play text that could then be sold to a publisher. Readers remembered what they had read, often writing down lines they had particularly enjoyed or admired. And in 1623, seven years after Shakespeare died, two old friends and fellow actors, John Heminge and Henry Condell, remembered their colleague, collecting his plays, eighteen of which had not previously been printed, in the volume now known as the First Folio, in order "to keepe the memory of so worthy a Friend, and Fellow, aliue, as was our SHAKESPEARE" (fig. 2).

And his memory was kept alive, though the process was more fitful and fraught than we imagine. Still, by 1814, his living memory enabled a character in Jane Austen's *Mansfield Park* to say that "we all talk Shakespeare, use his similes, and describe with his descriptions." Maybe we don't remember our Shakespeare today quite as vividly as Austen's Edmund Bertram. "Brush Up Your Shakespeare," advised Cole Porter, recognizing the need for occasional refreshers but also recognizing the cultural capital that would accrue: "and they'll all kowtow" (fig. 1). Since the beginning we have brushed up our Shakespeare and also brushed our Shakespeare up. We remember him as best we can, and through our continuing acts of remembering—on stage, in the study, and in the classroom—he remains vitally alive for us today.

2

*Mr. William Shakespeares Comedies, Histories, & Tragedies. Published according to the True Originall Copies* (London, 1623). H 31 cm, W 20 cm. Beinecke Library, Yale University

Lett thy tonge nott claspe abr a myld
for y㶊 y㶊att so dwy㶊ys may㶊 be cy㶊ng to hur hurtt

Thomas Dowse his boock

A man withowte mercy of mercy shall mys
and he shall have mercy that mercy full ys

Thomas Dayse his name

huge rocks, huggy windes, stronge pirats, shelues and san[ds]
the Marchantes feares, are rich at home he lands.

huge rocks, high windes, strong pirats, shelues & sands,
the Marchont feares, are rich at home he lands.

A man without mercy of mercy shall mis
and he shall                                    Thomas Doyse

        Thomas Doyse is
A man without mercy of mercy shall mis
and he shall

I  *The Beginnings to 1616*

Sometime after 1594, a young Englishman, Thomas Dowse, sat down with his copy of Peter Idle's *Instructions to his Son,* possibly not to read the book but merely to practice his handwriting on its endpapers. He writes his name again and again among the quotations he remembers from books he had read by, among others, Erasmus, William Warner, and Shakespeare. "Huge rocks, high winds, strong pirates, shelves and sands, the Merchant fears, ere rich at home he lands," Dowse twice records, in one of the earliest quotations of Shakespeare's long narrative poem, *Lucrece*. The lines, describing the risks that must be faced before eventual success, might well have appealed to an ambitious young man eager to make his way in late Elizabethan England, and so they took their place among the improving maxims and inspiring epigrams that Dowse copied into his book (fig. 3).

In 1598, John Marston, a playwright and poet, commented in his *Scourge of Villanie* on the habits of at least one Londoner who used the theater primarily as a source of sophisticated conversational gambits: "He writes, he railes, he jests, he courts, what not, / And all from out his huge long scrapped stock of / well penn'd playes." Marston jokes that he can tell the theater schedule by what Luscus says in public: "Luscus, what played today? Faith now I know. / I set thy lips abroach, from whence doth flow / Naught but pure Juliat and Romio."

For both Thomas Dowse and Marston's Luscus, Shakespeare was worth remembering not so much for complete and compelling works of great literature as for useful phrases and sentences excerpted from the plays and poems. Dowse read *Lucrece* and probably copied out the quotation he cites; "Luscus" perhaps went to the theater with a small notebook and copied down the phrases that would later mark his everyday attempts to be witty or charming. Neither, however, seems to have cared about the author of the words each sought to remember, but this should not be a great surprise. Shakespeare wasn't quite Shakespeare yet.

In 1600, *Englands Parnassus: or, the choysest Flowers of our Moderne Poets* (fig. 4) at least recorded Shakespeare's name. Organized as a commonplace book with excerpts arranged by topic, the book collects snippets of poetry by several dozen contemporary authors on subjects like Beauty, Pain, and Sight. "W. Shakespeare" (or merely "W. Sha." or "W. Sh.") provides some of these. On Beauty, "W. Shakespeare" notes that "All Orators are dumbe where Bewtie pleadeth," aphoristically weighing in on the subject along with many others, including Edmund Spenser, Michael Drayton, and William Weever. On Pain, "W. Sh." opines that "Paine paies the income of each precious thing." On Sight,

3
Annotations by Thomas Dowse in a manuscript copy of Peter Idle's *Instructions to his Son* (England, 16th century). Beinecke Library, Yale University

4

Robert Allott, *Englands Parnassus: or, The choysest Flowers of our Moderne Poets* (London, 1600). Beinecke Library, Yale University

5

Shakespeare's second sonnet. Commonplace book (England, mid-17th century). Beinecke Library, Yale University

6

William Shakespeare, *Venus and Adonis* (London, 1594). Elizabethan Club, Yale University

7

*The Most Excellent and lamentable Tragedie, of Romeo and Iuliet* (London, 1599). Elizabethan Club, Yale University

8

William Shakespeare, *The Most Excellent and Lamentable Tragedie, of Romeo and Ivliet* (London, 1622). Elizabethan Club, Yale University

"W. Sha." notes that "Often the eye mistakes, the braine being troubled," his judgment sharing the page with George Chapman, William Warner, and the now almost unknown Matthew Roydon.

Robert Allott, the compiler of *Englands Parnassus,* was confident that his collection of quotations would find eager readers: "I set my picture out to each mans vewe, Limd with these colours," he writes. But, revealingly, Shakespeare is but one color in the vibrant English poetic spectrum, and by no means the most prominent. Edmund Spenser (with 255 quotations) and Michael Drayton (with 163) both shine far brighter in this "picture" than Shakespeare, who — at least by one reader's citation count — ranked only as England's sixth "choysest flower" with 79 (but who might have still been happy to outshine George Chapman, with 69, and Ben Jonson, with 13).

It is this fragmented, excerpted Shakespeare, sociably bundled among his contemporaries, who first achieved literary prominence in the readers' notebooks and popular anthologies of the seventeenth century. Shakespeare's writing could take (or also lose) its place among the scribbles on the fly-leaves of a notebook, as in this copy of the second sonnet undistinguished and almost indistinguishable among epigrams and anagrams, riddles, songs, and poems (fig. 5). Like Thomas Dowse, Marston's Luscus, and the readers of *England's Parnassus*, this compiler snipped poems and plays in sound bites to be recited or recalled. Complete literary works trumpeting Shakespeare's genius would have to wait.

4

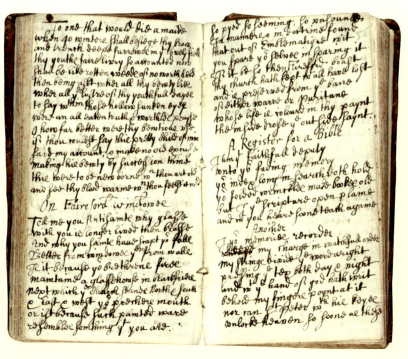

5

*Lucrece* (as the title page has it; the running title uses the more familiar *The Rape of Lucrece*) was printed in 1594 by Richard Field, who, like Shakespeare, had come to London from the Warwickshire town of Stratford-upon-Avon, some hundred miles to the northwest. The year before, Field had published another narrative poem by Shakespeare, *Venus and Adonis,* which would become the best-selling Shakespeare title in his own lifetime. Although Shakespeare almost certainly knew the publisher from their days together in their shared hometown, neither poem includes Shakespeare's name on the title page (fig. 6), though both include signed dedications by Shakespeare to the young Earl of Southampton.

Thomas Dowse may well have known who was the author of the lines he quoted, but he includes no attributions, though happily recording over and over that this is "his book." And, though "Luscus" remembered "Juliat and Romio" from a recent trip to the theater, he may well not have known the playwright's name. Theatrical productions would have been advertised only by the name of the acting company; even had he read the play in the single edition that had appeared in print by 1598, he would not have found Shakespeare's name on its title page, as he wouldn't when it was next published in 1599 (fig. 7), or published again after that. Indeed it was not until 1622, six years after Shakespeare died, that his name appeared on the title page of an edition of the play (fig. 8). It did so then only when the publisher, John Smethwick, belatedly discovered that

6

7

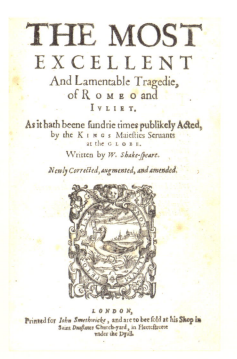

8

## The Stationer to the Reader.

To set forth a booke without an Epistle, were like to the old English prouerbe, A blew coat without a badge, & the Author being dead, I thought good to take that piece of worke vpon mee: To commend it, I will not, for that which is good, I hope euery man will commend, without intreaty: and I am the bolder, because the Authors name is sufficient to vent his worke. Thus leauing euery one to the liberty of iudgement: I haue ventered to print this Play, and leaue it to the generall censure.

Yours,

Thomas VValkley.

Shakespeare might be a marketable name, when the consortium that was putting together the so-called First Folio negotiated with him for the copyrights he held.

Copyright, it must be remembered, belonged then to publishers, not to authors, so a publisher was not required to acknowledge authorship or even to ensure an authorized edition of the text. Such commitments were commercial decisions, not legal obligations. In 1624, George Wither commented bitterly that the existing regulations served only the publisher's interests at the expense of both the author and the reader: "If he gett any written Coppy into his power, likely to be vendible; whether the Author be willing or no, he will publish it; and it shall be contriued and named alsoe, according to his owne pleasure, which is the reason so manie good Bookes come forth imperfect, and with foolish titles."

By 1622, it was obvious to some that a book with Shakespeare's name on it was "vendible," as Wither says. Shakespeare's name would sell books, not only on the evidence of Smethwick's reissue of the title page of *Romeo and Juliet,* but also on the explicit testimony of Thomas Walkley, the publisher of *Othello* in that year, who apologizes for his short prefatory note by admitting that "The Authors name is sufficient to vent (i.e., vend) his books" (fig. 9). It didn't always matter if Shakespeare actually wrote the book, as the edition of *The London Prodigal* proves, published in 1605, as "By William Shakespeare" (fig. 10), though this is more likely evidence of ignorance rather than cynicism on the part of the publisher.

What is clear, however, is that Shakespeare belatedly emerges as an *author* in large part as a function of commercial concerns. He was created as "Shakespeare" more by his publishers' ambitions than his own literary aspirations. His earliest published plays announced themselves only as they were "sundry times publiquely acted," as the 1599 edition of *Romeo and Juliet* has it, eight appearing in print before the first that included his name on the title page in 1598. And even when Shakespeare's name began regularly to appear on title pages along with, or even instead of, the name of the acting company, this had nothing to do with any legal or ethical obligation to recognize the playwright's intellectual property. Even the most insistent assertion of his authorship, the title page of the 1608 edition of *King Lear,* which announces the play as "M. William Shak-speare: / HIS / True Chronicle Historie of the life and death of King LEAR and his three Daughters" (fig. 11), proves the point. The trumpeting of Shakespeare's name is designed less to celebrate the playwright's artistic powers than to capitalize on his reputation and serve the publisher's desire to differentiate on the bookstalls what was in reality "HIS" play from the property

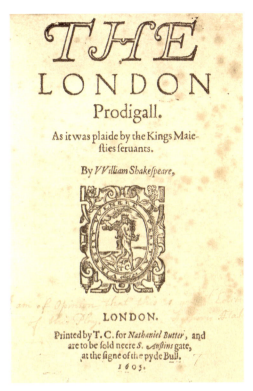

10

*The London Prodigall. As it was plaide by the Kings Maiesties seruants. By VVilliam Shakespeare* (London, 1605). Elizabethan Club, Yale University

9

William Shakespeare, *The Tragoedy of Othello, the Moore of Venice* (London, 1622). Elizabethan Club, Yale University

11

*M. William Shak-speare: His True Chronicle Historie of the life and death of King Lear and his three Daughters* (London, 1608). Beinecke Library, Yale University

12

"A dogge, so bade in office," in *M. William Shak-speare: His True Chronicle Historie of the life and death of King Lear and his three Daughters* (London, 1608). Beinecke Library, Yale University

13

Wenceslaus Hollar, *A View from St. Mary's, Southwark, Looking Towards Westminster* (c. 1638). Yale Center for British Art, Paul Mellon Collection, Yale University

*Lear.* And the creature runne from the cur, there thou mightst behold the great image of authoritie, a dogge, so bade in office, thou rascall beadle hold thy bloudy hand, why dost thou lash that whore, strip thine owne backe, thy bloud hotly lusts to vse her in that kind for which thou whipst her, the vsurer hangs the cosioner, through tottered ragges, smal vices do appeare, robes & furd-gownes hides all, get thee glasse eyes, and like a scuruy politian seeme to see the things thou doest not, no now pull off my bootes, harder, harder, so.

of another publisher, who several years earlier had published the anonymous *True Chronicle History of King Leir.*

The publisher of *King Lear,* Nathaniel Butter, was obviously eager to assert Shakespeare's authorship but less concerned about the text itself. It is a poorly printed play with a number of obvious errors, and Shakespeare seems neither to have overseen the printing nor to have been concerned about the result. Shakespeare's cynical political observation that "a dog's obeyed in office" appears as "a dogge, so bade in office" (fig. 12), perhaps suggesting that the manuscript from which the text was printed was copied down during a performance, the spoken lines misheard. But in any case Butter was not much concerned to get the text exactly right. For him *King Lear* was a popular play, not a great work of literature. His goal was to print the play quickly and cheaply, and hope that playgoers who had enjoyed it in the theater would buy a copy of the inexpensive pamphlet he had produced.

Plays were not yet literature, but a form of public entertainment. In the bustle of London, plays would have been only one amusement, one distraction in the often plague-ridden, sometimes squalid, usually loud, always expensive, and inevitably lively city. A view of its dense streets can be had in the drawings (c. 1638) by the Bohemian artist Wenceslaus Hollar (fig. 13), showing the city to the east and west from St. Mary Overy in Southwark. The Globe is visible but hardly conspicuous in the middle distance, reflecting more or less how it would have been understood by its contemporaries, several decades after its construction and the death of its best-remembered landlord, as one building among many in the panorama of London. Southwark was a district with

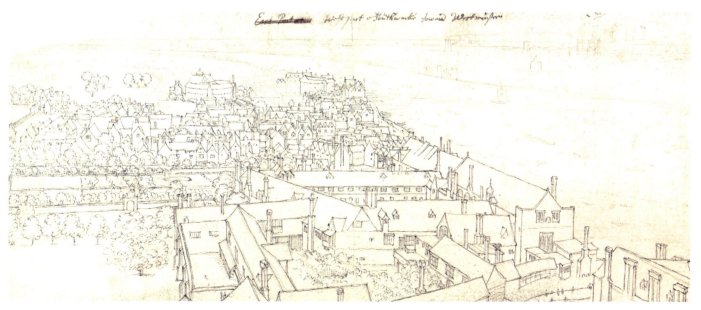

13

14

15

"diverse streets and winding lanes," as a contemporary described it, providing homes for theaters, bear-baiting gardens, brothels, and five prisons. Some of its more respectable inhabitants appear on this list of the offices funded by the Crown: the "Players of interludes"—including Richard Burbage, John Heminge, and John Lowin—but also the "Keeper of Parrys garden, of beares and mastifs" (fig. 14).

It is then no surprise to find that the playbooks generally had little cultural cachet. They recorded the scripts, whether those of Burbage and Heminge's acting company, the King's Men, or Edward Alleyn and Philip Henslowe's Admiral's Men, and, when published at all, were cheaply printed in quarto form, the small format that functioned more or less as a modern paperback. Thomas Bodley, the founder of what would become the Bodleian Library at Oxford University, in spite of his desire to include all books printed in England, instructed his librarian in 1612 not to collect printed plays lest some "scandal" attach to the library by their presence in the collection. Commercial plays were part of the "riffe-raffes" and "baggage bookes" that he would conscientiously exclude. They were popular entertainments, written not by immortal authors but by theater professionals, sometimes known as "play-patchers." Plays were collaborations, not just in the case of those written or revised by various writers, who might contribute to the plot, update a scene, write a prologue, or provide the lyrics to a song; in every case, plays were made in part also through the labor of other people: actors, musicians, dancers, carpenters, tailors. Included here, for example, is the only contemporary setting of the music for Benedick's song in Act Five of *Much Ado About Nothing* (fig. 15), certainly part of the play but not by Shakespeare.

Largely because of this, printed playbooks, even the edition of *King Lear*, were quickly produced and casually proofread. The gatherings of leaves were usually stab-stitched rather than sewn, and the pamphlet itself most likely covered in paper wrappers or bound in cheap leather. Only later would these become priceless literary relics. The beautiful tooled bindings of Shakespeare's quartos that can often be seen today in rare book libraries are inevitably expensive nineteenth- and twentieth-century custom bindings of what was originally a form of cheap print. In their own time, they were largely commemorative, records of a theatrical production that had no other means of being preserved. The six-penny pamphlets were a relatively cheap way of recalling a performance or catching up with one that had been missed. Thus, in 1628, the publisher of an edition of a play by Beaumont and Fletcher, Shakespeare's successors as the chief playwrights of the King's Men, hopes that it will be "eagerly sought for, not onely by those that haue heard & seene it, but by others that haue merely heard thereof."

14
The offices of England collected according to the yeare of 1607 (England, 1607). Beinecke Library, Yale University

15
The Braye Lute Book. Commonplace book (England, 16th century). Beinecke Library, Yale University

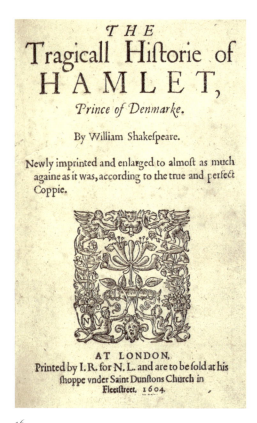

16
William Shakespeare, *The Tragicall Historie of Hamlet, Prince of Denmarke* (London, 1604). Elizabethan Club, Yale University

17
In the margin, an anagram: "Elisabeth Rotton / Her lot is to b neat." William Shakespeare, *The Most Excellent and lamentable Tragedie, of Romeo and Iuliet* (London, 1599). Elizabethan Club, Yale University

All too few of these pamphlets have survived, just nine copies of the second edition of *Hamlet* (fig. 16), for example, and only two of the first edition (the so-called bad quarto). The ones that have survived sometimes give evidence of attentive reading, but more often not. The Yale copy of the 1599 quarto of *Romeo and Juliet,* for example, shows someone carefully correcting a speech heading, but also includes in the margin a carefully written anagram, wonderfully irrelevant to the text it adorns: "Elisabeth Rotton / Her Lot is to b neat" (fig. 17).

Still, Shakespeare's reputation, a literary reputation, did grow. In 1592 Robert Greene, a contemporary playwright and pamphleteer, could dismissively refer to him as an ambitious new boy on the block merely imitating what his betters had done before. Shakespeare, says Greene, is "an upstart Crow, beautified with our Feathers, that with his *Tygres head* [heart, in 1592] *wrapt in Players hyde,* supposes hee is as well able to bombast out a Blanke verse as the best of you: and being an absolute *Iohannes fac totum*, is in his owne conceit the onely Shake-scene in a Countrey" (fig. 18). Greene dismisses the literary presumption of the young actor ("wrapt in a Players hide," echoing Shakespeare's "O, tiger's heart wrapped in a woman hide" from *Henry VI, part three*). But six years later Francis Meres would acknowledge that Shakespeare had taken his place among the best of the English writers of his time, worthy of comparison with the ancients: "As *Plautus* and *Seneca* are accounted the best for Comedy and Tragedy among the Latines : so *Shakespeare* among ye English is the most excellent in both kinds for the stage; for Comedy, witnes his *Ge[n]tleme[n] of Verona*, his *Errors*, his *Love labors lost*, his *Love labours wonne*, his *Midsummer night dreame*, & his *Merchant of Venice* : for Tragedy his *Richard the 2. Richard the 3. Henry the 4. King John, Titus Andronicus* and his *Romeo and Juliet*." And Meres also praises the poetry: "As the soule of *Euphorbus* was thought to live in *Pythagoras:* so the sweet wittie soule of *Ovid* lives in mellifluous & honytongued *Shakespeare*, witnes his *Venus* and *Adonis*, his *Lucrece*, his sugred Sonnets among his private friends, &c." (fig. 19).

By the time Shakespeare died in 1616, eighteen plays had reached print, ten of which had been published in multiple editions. That of course means that eight of these were *not* deemed popular enough to demand a second edition, but the eighteen plays, published in at least forty-two separate editions, do show that Shakespeare had no equal among his fellow playwrights for preeminence in the bookstalls. In our various measures of his excellence we usually forget that in his own age more editions of his plays circulated than of any other playwright. His best selling plays were *Henry IV, part one*, with six editions, and *Richard II* and *Richard III*, each with five. *Lucrece*, one of his two long

*The most lamentable Tragedie*

*Iul. Ro.* O God I haue an ill diuining soule,
Me thinkes I see thee now, thou art so lowe,
As one dead in the bottome of a tombe,
Either my eye-sight failes, or thou lookest pale.

  *Rom.* And trust me loue, in my eye so do you:
Drie sorrow drinkes our bloud. Adue, adue.

*Exit.*

  *Iu.* O Fortune, Fortune, all men call thee fickle,
If thou art fickle, what dost thou with him
That is renowmd for faith? be fickle Fortune:
For then I hope thou wilt not keepe him long,
But send him backe.

*Enter Mother.*

  *La.* Ho daughter, are you vp?
  *Iu.* Who ist that calls? It is my Lady mother.
Is she not downe so late or vp so early?
What vnaccustomd cause procures her hither?
  *La.* Why how now *Iuliet*?
  *Iu.* Madam I am not well.
  *La.* Euermore weeping for your Cozens death?
What wilt thou wash him from his graue with teares?
And if thou couldst, thou couldst not make him liue:
Therfore haue done, some griefe shews much of loue,
But much of greefe, shewes still some want of wit.
  *Iu.* Yet let me weepe, for such a feeling losse.
  *La.* So shall you feele the losse, but not the friend
Which you weepe for.
  *Iu.* Feeling so the losse,
I cannot chuse but euer weepe the friend.
  *La.* Wel gyrle, thou weepst not so much for his death,
As that the villaine liues which slaughterd him.
  *Iu.* What villaine Madam?
  *La.* That same villaine *Romeo*.
  *Iu.* Villaine and he be many miles a sunder:
God padon, I do with all my heart:
And yet no man like he, doth greeue my heart.

*La.* That

### Greenes Groatf-worth of wit.

And thou no lesse deseruing then the other two, in some things rarer, in nothing inferiour, driuen (as my selfe) to extreame shifts, a little haue I to say to thee: and were it not an idolatrous oath, I would sweare by sweet S. George, thou art vnworthy better hap, sith thou dependest on so meane a stay. Base minded men all three of you, if by my misery yee be not warned: for vnto none of you (like me) sought those burs to cleaue: those Puppets (I meane) that speak from our mouths, those Anticks garnisht in our colours. Is it not strange that I, to whom they all haue bin beholding: is it not like that you, to whom they all haue bin beholding, shall (were yee in that case that I am now) be both of them at once forsaken? Yes trust them not: for there is an vpstart Crow beautified with our Feathers, that with his Tygres head, wrapt in a Players hyde, supposes hee is as well able to bombast out a Blanke verse, as the best of you: & being an absolute *Iohannes fac totum*, is in his owne conceit the onely Shake-scene in a Countrey. Oh that I might intreat your rare wittes to be imployed in more profitable courses: and let these Apes imitate your past Excellence, & neuer more acquaynte them with your admyred Inuentions. I know the best Husband of you all wil neuer proue an Usurer, and the kindest of them all will neuer proue a kinde Nurse: yet whilst you may, seeke you better Maisters: for it is pitty men of such rare wits should be subiect to the pleasures of such rude groomes.

In this I might insert two more, that both haue writ against these buckram Gentlemen: but let their owne worke serue to witnesse against their owne wickednesse if they perseuer to maintaine any more such peasants. For other new commers, I leaue them to the mercie of these painted monsters, who (I doubt not) will driue the best minded to despise them: for the rest, it skils not though they make a iest at them.

But now returne I againe to you three, knowing my

18
Robert Green, *Greenes Groatsworth Of VVitte: Bought with a million of Repentance* (London, 1621). Beinecke Library, Yale University

19
Francis Meres, *Palladis Tamia. VVits Treasury Being the Second part of Wits Common wealth* (London, 1598). Beinecke Library, Yale University

narrative poems, had also appeared in six editions, while the other, *Venus and Adonis*, emerged as Shakespeare's biggest seller, with ten editions published before his death. The *Sonnets*, published in 1609, were not republished while Shakespeare was alive, though individual poems, as we have seen, circulated in manuscript both before and after the publication of the book.

The play that Francis Meres referred to as "*Love labours wonne*" seems not have survived in any form or is an alternative title for an existing play (though there is no obvious candidate). A scrap of a book list from 1603 includes the "marchant of vennis, taming of a shrew,… loves labor lost, loves labor won," so there is additional evidence that the play once existed. But many early books, especially cheap pamphlets, have disappeared, probably forever—even plays by Shakespeare.

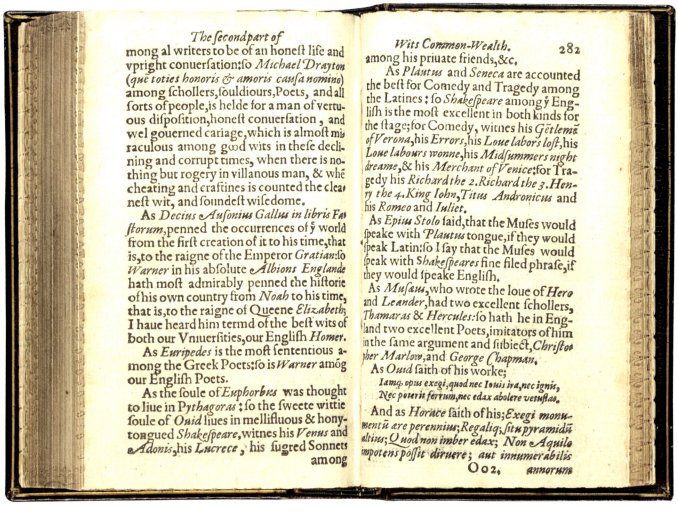

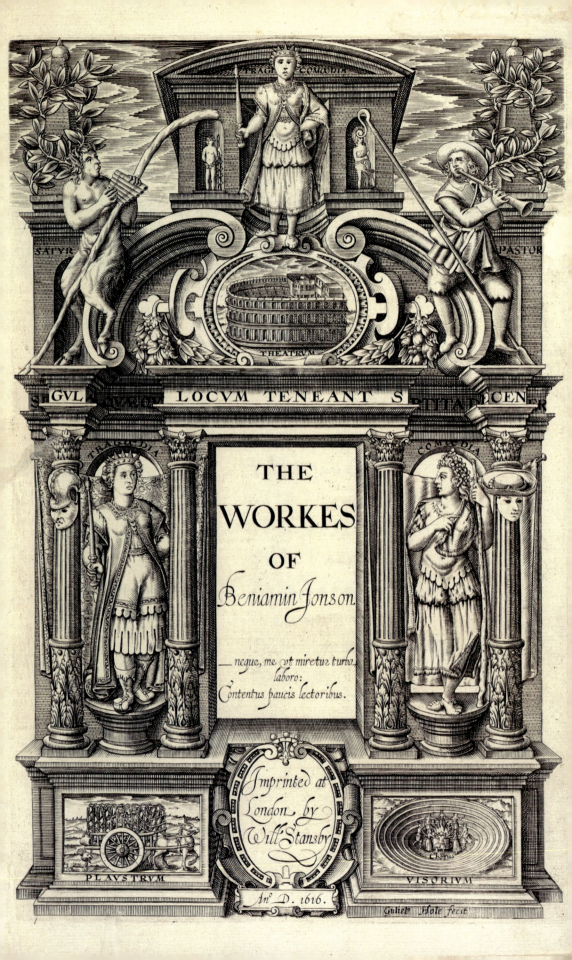

## II  *Shakespeare Invented*

In 1616, the very year in which Shakespeare died, an impressive folio volume including nine plays and numerous poems was published by William Stansby, though not, as one might have expected, of Shakespeare's works, but of the *Workes of Beniamin Jonson* (fig. 20). Jonson was a friend of Shakespeare and a fellow playwright, and the volume of his *Workes* includes poems, 133 numbered epigrams, masques and entertainments written for royal or aristocratic patrons, as well as the nine plays for the commercial theater. This was, it might be said, the *first* First Folio.

It was the inclusion of the plays that caused the greatest surprise, since plays were still largely thought to be sub-literary. An anonymous bit of contemporary doggerel puns: "Pray tell me *Ben*, where doth the mystery lurke, / What others call a play you call a work." But there is no mystery here: Jonson was making an audacious and unprecedented claim for the cultural status of his plays. In 1600 he had become the first playwright to insist upon himself as an "author" on the title page of a printed play, *Every Man Out of His Humour*, which was published "AS IT WAS FIRST COMPOSED by the Author B.I." and as "*Containing more than hath been publickely spoken or acted*" (fig. 21). The printed play is no longer imagined as a record of collaborative performance, but as a literary text by a single author. And now the folio volume, with its frontispiece designed as a self-conscious bit of classicizing, would set Jonson further apart from the theatrical world, tying him not to the ephemera of the contemporary stage but to the enduring monuments of the classical past.

Shakespeare never gave any evidence of a similar literary ambition beyond the quality of what he wrote. Though publishers understood that Shakespeare's name might sell books, Shakespeare's own ambitions seem to have been satisfied by the successes of the theater company. He never turned to print, as some other playwrights did, to assert the integrity of what we might call his "intellectual property." Thomas Heywood, for example, consented "to commit [his] plaies to the presse," but only, or so he insisted, to replace the "corrupt and mangled" versions that had "accidentally come into the Printers hands." But Shakespeare never offered even this proprietary reason to oversee an edition of any of his plays, although a number of them arrived at the printer as "accidentally" as those of Heywood, and some were printed in versions every bit as "corrupt and mangled." Though some editions of Shakespeare's plays did appear claiming on their title pages to be "corrected" or "amended,"

20
Ben Jonson, *The Workes of Beniamin Jonson* (London, 1616). Beinecke Library, Yale University

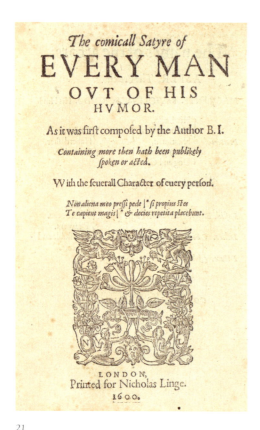

21

Ben Jonson, *The comicall Satyre of Every Man Ovt Of His Hvmor. As it was first composed by the author B.I.* (London, 1600). Elizabethan Club, Yale University

these claims were never made by Shakespeare himself, and indeed no play of his appears in print with an authorial preface of any kind.

Authorship seems not to be the primary category that defined Shakespeare's relationship to the theater. He was, as Robert Greene had earlier noted, a *Johannes fac totum*, a jack of all trades: one of the "principall Tragoedians," as the cast list for Jonson's *Sejanus* shows (fig. 22), and in fact a shareholder in the acting company, entitled to ten percent of its profits and, of course, with a similar liability for any losses. He was the company's leading playwright, but any literary ambitions of his own were subordinated to the company's interests, which paid so much better. Eighteen of the plays he wrote were never published in his lifetime.

Usually an acting company had little to gain — and possibly much to lose — by allowing its scripts to reach print. A publisher would pay no more than about two pounds for a playbook, not an inconsequential sum but less than a good day's take at the box office, and publication might well give another company access to its repertory. In 1633, Thomas Heywood noted that a number of his plays were "retained in the hands of some actors, who think it against their peculiar profit to have them come in print."

Still, editions of some plays by Shakespeare did find their way into print, though inconsistently, usually only one or two a year. In 1600, eight were published, the most in any year of his lifetime. But none was published in 1601. Three appeared in 1602; one in 1603; two were published in 1604; one in 1605; none in 1606 or 1607; three in 1608; four (including two editions of *Pericles*) in 1609; none in 1610; three in 1611; one in 1612; one in 1613; none in 1614; one in 1615. None appeared the next year, the year he died, and none in the two years following. Neither in the last years of his life, nor in the years immediately after he died, were Shakespeare's plays a hot property for the publishing business.

It is hard to imagine now that this could have been the case, but it was — and might easily have stayed that way. Reading history backwards, it seems inevitable that Shakespeare's plays were valuable titles for publishers. But they weren't. We assume they must always have been best sellers. Some were; most were not, and from 1614 until 1619 only one play was printed. In 1619, then, Shakespeare might well have seemed more likely to disappear from the bookstalls than to become the best-selling playwright of all time.

Arguably, what saved him for posterity was the ambition of a single London publisher, Thomas Pavier, though usually he is more excoriated than praised for his efforts. In 1619, Pavier, along with a printer, William Jaggard, set out to print an edition of Shakespeare, not in the cheap pamphlet form in which the individual plays had been published but in a bound edition of

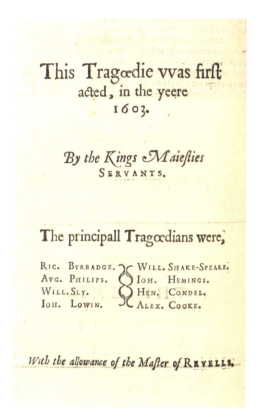

22
The cast list for *Sejanus, his Fall*. In Ben Jonson, *The Workes of Beniamin Jonson* (London, 1616). Beinecke Library, Yale University

selected plays. What has kept Pavier's role from being properly acknowledged is that the project was interrupted, seemingly by Shakespeare's former theatrical colleagues exerting pressure to stop the publication.

A note dated 3 May 1619 in the records of the Stationers' Company (the guild responsible for the organization and regulation of the publishing business), indicates that the Lord Chamberlain, the chief official in the Royal Household, had written to the company officers requesting their help in preventing plays in the repertory of the King's Men, the acting company in which Shakespeare had been a "sharer," from being published without their permission. The King's Men did not want their plays published without their consent, and the Stationers agreed to respect their wishes. The *request,* if that is the right term for what the Lord Chamberlain is likely to have sent, was made not on some legal ground of intellectual property, for that idea had no force in law until 1710. A Stationer could print what he owned, and he owned what he had bought, whether it was purchased from the author or not. But the Stationers' court was unlikely to push the principle; Shakespeare's company of actors was, after all, the King's Men. The note in the records thus predictably reads: "It is thought fitt & so ordered That no playes that his Ma$^{tyes}$ players shalbe printed w$^{th}$ out consent of som*me* of them."

Scholars knew nothing at all of Pavier's project until 1905. A prominent English bibliographer, A.W. Pollard, had been approached by a German collector, who "had found, among the treasures of a library formed by a book-loving ancestor … a volume containing nine plays with all of which Shakespeare's name has been connected." The gentleman came to London with his book, and soon, Pollard excitedly wrote, "the fat little volume was in my hands."

Pollard examined the book and discovered it in fact contained ten plays seemingly published at various times between 1600 to 1619 and by various publishers: versions of *Henry VI, parts two and three* (treated as a single play in two parts: *The Whole Contention Between the Two Famous Houses, Lancaster and York*), *Pericles, A Yorkshire Tragedy, The Merchant of Venice, The Merry Wives of Windsor, King Lear, Henry V, Sir John Old-castle,* and *A Midsummer Night's Dream*. Initially this seemed to be a personalized anthology, individual plays collected and bound together by some reader, but Pollard soon discovered another book containing the same ten plays but bound in a different order. That set him off searching for more, and he found in the Capell collection at Trinity College Cambridge the same ten plays bound in two volumes, and then learned that the University of Virginia had at one time owned a bound volume of the same plays, which had been given to the University by Thomas Jefferson's son-in-law, but which had been destroyed in a fire in 1895. Later, painstaking bibliographic analysis

23
The first page of R signature in Thomas Pavier's edition. William Shakespeare, *The Late, And much admired Play, Called Pericles, Prince of Tyre* (London, 1619). Beinecke Library, Yale University

24
*A Yorkshire Tragedie. Not so New, as Lamentable and True. Written by W. Shakespeare* (London, 1619). Beinecke Library, Yale University

25
*The first part Of the true & honorable history, of the Life of Sir Iohn Old-castle, the good Lord Cobham* (London, 1600 [i.e. 1619]). Beinecke Library, Yale University

26
*The Whole Contention betweene the two Famous Houses, Lancaster and Yorke* (London, [1619]). Elizabethan Club, Yale University

revealed that all of the plays were printed at the same time and in the same printing house, the title page information in some cases obviously falsified.

Three of the plays, the two plays of *The Whole Contention* and *Pericles*, have continuous signatures, that is, they were printed to be bound consecutively as part of a single book. (Early printed books in small formats rarely have page numbers; the lettered signatures at the bottom of the pages allowed a binder to get the pages into the proper order.) The sequential signatures are exactly as if the first title ran from page 1–50 and the second from 51–75. Thus, Pavier's two-part play, *The Whole Contention*, begins on signature A2$^r$ (the second part of the play, what we know as *Henry VI, part three*, beginning on signature I1$^r$), and *Pericles* begins on R1$^r$ (fig. 23). A1$^r$ is the cover page.

Clearly, then, these were intended to be part of a single publication, though the other seven plays (here counting the continuously paged *1 Henry VI, parts two and three* as one) have their own independent signatures, each beginning with A. Something changed, and that something was almost certainly the Lord Chamberlain's letter. We don't know for certain that it was Pavier's project that motivated the Lord Chamberlain's intervention on behalf of the actors, but the quick agreement to it by the Stationers' Court at least must have made Pavier anxious about his own venture. The falsely dated title pages and the abandonment of the continuous signatures may have been just enough to give Pavier deniability in case his publication aroused further concern from them. Which in the event it doesn't seem to have done. He printed his nine quartos in spite of the Court's order, and the plays were offered for sale both individually and as a collection, though few complete copies survive. Still, a relatively large number of individual copies of the so-called "Pavier Quartos" exists today. The survival rate is far greater than of earlier editions of any of these plays, and indeed of later ones, which is almost certainly a function of the fact some significant number were bound and bought together, and only later disaggregated and rebound individually.

But if the Lord Chamberlain's letter did not stop Pavier from publishing these plays, it did prevent him from advertising his collection *as* a collection. He never printed a title page for the volume as a whole (or at least none has survived), and that fact has obscured what seems most noteworthy about the project: it is the first collected edition of Shakespeare's plays, even if two of those he published, *A Yorkshire Tragedie* (fig. 24) and *The First Part of the … Life of Sir Iohn Old-castle* (fig. 25) are not now thought to be by Shakespeare at all. Some of his intentions, though, can perhaps be sensed from the title page to *The Whole Contention*, which advertises it as by "*William Shakespeare*, Gent." (fig. 26), the first time Shakespeare's name appears on a printed play with this designation of social status.

Instead of being celebrated for his publishing acumen, Pavier, for the most part, has been condemned for the enterprise: for setting himself in opposition to the players' desire to keep their own scripts private, for fraudulently trying to avoid detection, for sneaking in, as Shakespeare's, works by lesser dramatists, and for publishing others that he may not have owned. The evidence, however, tells a somewhat different story, though this is not the place to tell it.

What matters here is that Pavier is the first person to imagine Shakespeare's plays as a book. And he did so even though no play by Shakespeare had appeared in print for four years prior to his project. One might say then that he revived interest in Shakespeare, perhaps even that he provoked the First Folio. But certainly Shakespeare as an author originates with Pavier's collection. Shakespeare never imagined himself that way: Pavier was the first person to do so. His project was the first attempt to materialize Shakespeare as an author in the form of a bound book. Before his "fat little volume" there were only fragile and disposable pamphlets of the plays. Pavier, it might be said, is the man who invented "Shakespeare." But like a lot of inventions, this too would take the efforts of others to realize it fully.

## To the Reader.

This Figure, that thou here seeſt put,
   It was for gentle Shakeſpeare cut;
Wherein the Grauer had a ſtrife
   with Nature, to out-doo the life :
O, could he but haue drawne his wit
   As well in braſſe, as he hath hit
His face ; the Print would then ſurpaſſe
   All, that was euer writ in braſſe.
But, ſince he cannot, Reader, looke
   Not on his Picture, but his Booke.

                                      B. I.

Mr. WILLIAM
# SHAKESPEARES
### COMEDIES, HISTORIES, & TRAGEDIES.

Publiſhed according to the True Originall Copies.

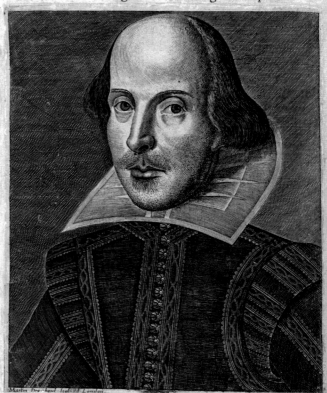

Martin Droeſhout ſculpſit London.

*LONDON*
Printed by Iſaac Iaggard, and Ed. Blount. 1623.

# III  *Shakespeare Monumentalized*

The book the world knows as the "First Folio" is not, of course, the 1616 folio edition of Jonson's *Workes,* but rather the collection of Shakespeare's plays published seven years later: thirty-six plays arranged in double columns, printed in a pica roman typeface on 227 sheets of crown paper. This is the iconic book that has become one of the most valuable printed books in the world — one sold at auction for over six million dollars in 2006 — though it is Shakespeare who gives the book its value rather than its scarcity. Of the 800 or so copies that were printed, some 230 have survived. But more significant than any price tag is that the book succeeded in doing what Pavier only hoped to do: establish Shakespeare as an "author." MR. WILLIAM SHAKESPEARES COMEDIES, HISTORIES, & TRAGEDIES announces the title, plays all "Published according to the True Originall Copies" (fig. 27).

Admittedly "Originall Copies" sounds to our ears like an oxymoron, but "Copies" here does not mean "reproductions" or "facsimiles," but rather "texts" or "versions"; i.e., the title page is claiming that these are the authentic and original versions of the plays. The title stands above the famous engraving of Shakespeare by Martin Droushout, and the severe portrait, with its old-fashioned ruff, seemingly itself guarantees the authenticity of the play texts within. Shakespeare's hooded and intelligent eyes engage the viewer, but the short poem by Ben Jonson on the facing page tells us we are in fact looking at the wrong thing. It tells us to look away even as it praises the engraver's artistry: "O, could he but haue drawne his wit / As well in brasse, as he hath hit / His face, the Print would then surpasse / All that was euer writ in brasse. / But, since he cannot, Reader, looke / Not on his Picture, but his Booke."

The title page and the facing poem set out a compelling double-barrelled claim, offering both what is authentically by Shakespeare and what is most authentically Shakespeare himself. But is it true? Is this indeed what Shakespeare looked like? Certainly we have no better evidence. Jonson's testimony to the accuracy of the portrait of someone he knew well and the fact that the volume was in part put together by two friends who had known Shakespeare from his earliest days as an actor in London both suggest that Droushout had indeed produced a recognizable likeness. Nonetheless, the figure's high forehead and unshaven round face have not always matched what readers have imagined their Shakespeare should look like, and every few years some portrait, usually of someone more dashing, is offered as the "real" Shakespeare, most recently the "Cobbe" portrait.

27
The title page and frontispiece of the First Folio. *Mr. William Shakespeares Comedies, Histories, & Tragedies. Published according to the True Originall Copies* (London, 1623). H 31 cm, W 20 cm. Beinecke Library, Yale University

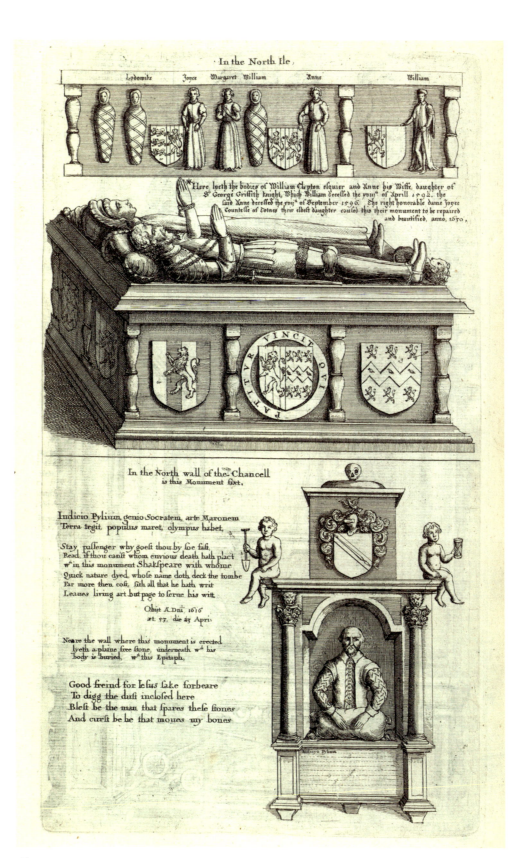

28

Shakespeare's memorial. William Dugdale, *The Antiquities of Warwickshire Illustrated* (London, 1656). Beinecke Library, Yale University

29

*The Works Of Mr. William Shakespear; In Six Volumes. Adorn'd with Cuts. / Revis'd and Corrected, with an Account of the Life and Writings of the Author. By N. Rowe, Esq;* (London, 1709). Beinecke Library, Yale University

The only other representation with claims to accuracy is that on the monument in Holy Trinity Church in Stratford-upon-Avon, which was erected sometime between Shakespeare's death in 1616 and the printing of the First Folio (since one of the dedicatory sonnets mentions it). Forty years after Shakespeare's death, an antiquarian, William Dugdale, included an engraving of the tomb in his illustrated guide to the historical memorials of Warwickshire. The engraving, cut from a sketch which he had made himself over twenty years earlier, shows an older and leaner Shakespeare (fig. 28). One or the other of these images would influence portraits of Shakespeare for the next hundred years, as, for example, on the title page of Nicholas Rowe's edition of Shakespeare published in 1709 (fig. 29), which clearly updates the Droushout engraving from the First Folio.

In any case Jonson had said that what Shakespeare looked like was less important than what he wrote, that in the words on the page we would really find Shakespeare, in the wisdom and wit of his writing rather than in the portrait of the man. So, does the First Folio indeed give us Shakespeare's "True

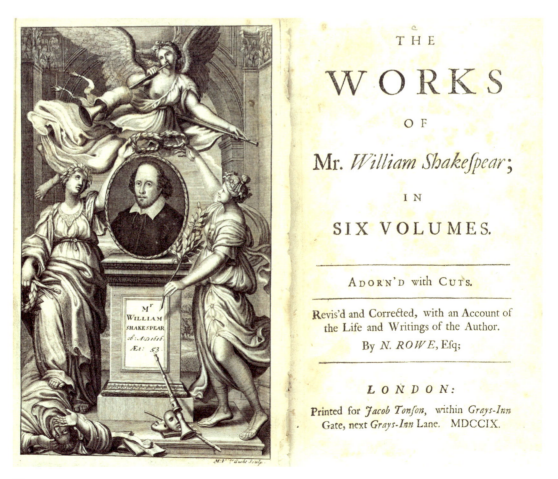

29

Originall Copies"? Certainly the book tries hard to convince its readers that it does. John Heminge and Henry Condell, in their prefatory epistle "To the great Variety of Readers," claim that previously readers of Shakespeare had been "abus'd with diuerse stolne, and surreptitious copies, maimed, and deformed by the frauds and stealthes of iniurious imposters, that expos'd them," but that now, in this new edition, these plays are "offer'd to your view cur'd, and perfect of their limbes, and all the rest, absolute in their numbers, as he conceiued the[m]" (fig. 30). The plays that had previously circulated only in degraded versions are here presented "cur'd" of their defects, while the eighteen plays that are printed for the first time in the Folio are set forth here in their untainted, ideal form.

The Folio, then, is offered to its readers as Shakespeare's Shakespeare, exactly as he "conceiu'd" it. But in truth this is not the case. The claim is mere advertising exaggeration: the plays previously in print were not as deformed as Heminge and Condell claim, nor are the new versions offered here anything close to "perfect." And the plays printed for the first time in the Folio are not as unadulterated as the two actors profess. The plays that appear in the First Folio are, in fact, of varying quality and emerge from various sources. Some seem to be based on authorial manuscripts (but remember that no manuscript of a Shakespeare play has survived, so even this claim is based on the idea that one can tell on the basis of the printed play what sort of copy it was printed from); others seem to show the effects of the theater and may well include cuts, changes, and interpolations made by actors. Some plays are printed from carefully prepared scribal copies; others from previously printed versions that have accumulated errors through their various editions. They display in their various forms both Shakespeare's willing embrace of the necessary collaborations of the theater company and his passive acceptance of the inescapable contaminations of the printing house. It is only our passionate desire for the authentic Shakespeare that has allowed us ever to take Heminge and Condell at their word.

Or at least at *that* word. Elsewhere in the prefatory materials of the First Folio is a revealing admission, certainly more compelling than the fantasy of textual purification that they set before us. Heminge and Condell offer the book to its hoped-for readers and invite them to value it as they see fit: "Iudge your␣six-pen'orth, your shillings worth, your fiue shillings worth at a time, or higher, so you rise to the iust rates, and welcome. But, what euer you do, Buy." They do, of course, urge that we read Shakespeare. "Reade him," they counsel, and "againe and againe"; but the bottom line, one might well say, is: "Buy."

We think, understandably, of the First Folio as a necessary monument to Shakespeare's greatness, the inevitable and appropriate tribute of the publish-

30
*Mr. William Shakespeares Comedies, Histories, & Tragedies. Published according to the True Originall Copies* (London, 1623). Beinecke Library, Yale University

## To the great Variety of Readers.

**F**Rom the most able, to him that can but spell: There you are number'd. We had rather you were weighd. Especially, when the fate of all Bookes depends vpon your capacities: and not of your heads alone, but of your purses. Well! It is now publique, & you wil stand for your priuiledges wee know: to read, and censure. Do so, but buy it first. That doth best commend a Booke, the Stationer saies. Then, how odde soeuer your braines be, or your wisedomes, make your licence the same, and spare not. Iudge your sixe-pen'orth, your shillings worth, your fiue shillings worth at a time, or higher, so you rise to the iust rates, and welcome. But, what euer you do, Buy. Censure will not driue a Trade, or make the Iacke go. And though you be a Magistrate of wit, and sit on the Stage at *Black-Friers*, or the *Cock-pit*, to arraigne Playes dailie, know, these Playes haue had their triall alreadie, and stood out all Appeales; and do now come forth quitted rather by a Decree of Court, then any purchas'd Letters of commendation.

It had bene a thing, we confesse, worthie to haue bene wished, that the Author himselfe had liu'd to haue set forth, and ouerseen his owne writings; But since it hath bin ordain'd otherwise, and he by death departed from that right, we pray you do not envie his Friends, the office of their care, and paine, to haue collected & publish'd them; and so to haue publish'd them, as where (before) you were abus'd with diuerse stolne, and surreptitious copies, maimed, and deformed by the frauds and stealthes of iniurious impostors, that expos'd them: euen those, are now offer'd to your view cur'd, and perfect of their limbes; and all the rest, absolute in their numbers, as he conceiued thē. Who, as he was a happie imitator of Nature, was a most gentle expresser of it. His mind and hand went together: And what he thought, he vttered with that easinesse, that wee haue scarse receiued from him a blot in his papers. But it is not our prouince, who onely gather his works, and giue them you, to praise him. It is yours that reade him. And there we hope, to your diuers capacities, you will finde enough, both to draw, and hold you: for his wit can no more lie hid, then it could be lost. Reade him, therefore; and againe, and againe: And if then you doe not like him, surely you are in some manifest danger, not to vnderstand him. And so we leaue you to other of his Friends, whom if you need, can bee your guides: if you neede them not, you can leade your selues, and others. And such Readers we wish him.

A 3

*Iohn Heminge.*
*Henrie Condell.*

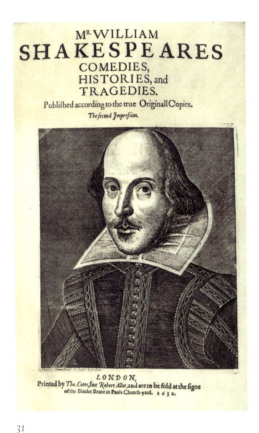

31
*Mr. William Shakespeares Comedies, Histories, and Tragedies. Published according to the true Originall Copies* (London, 1632). Beinecke Library, Yale University

ing industry to the playwright's genius. But for the publishers of the First Folio, Shakespeare was business, in fact risky business, undertaken at considerable expense and with no guarantee of recovering the investment. For its printers, William Jaggard and his son Isaac, it was, however, a time-consuming commitment occupying their presses, which might well have been used for more important projects, like Augustine Vincent's *Discoverie of Errours in the first edition of the Catalogue of Nobility published by Raphe Brooke, Yorke Herald,* which the Jaggards interrupted the printing of the First Folio to complete.

But if the book was not first among the Jaggards' priorities, it was unquestionably an important book for them, advertised before it was finished in the catalogue of the Frankfurt Book Fair in 1622. The First Folio does not so much celebrate Shakespeare's greatness as create it, not least by preserving eighteen plays that would likely have been lost to time, including *As You Like It, Twelfth Night, Macbeth,* and *The Tempest,* and establishing Shakespeare in its structure as the author he never sought to be. But it did so neither as confidently as it seems in retrospect nor for motives quite as noble or disinterested as claimed. In the publication of the First Folio, Shakespeare was re-membered and remembered, as the corpus of his works was assembled as a marketable commodity after his death.

In the event, the publishing project was a success. A second edition appeared nine years later in 1632; Jonson's folio, by contrast, would wait twenty-four years to justify a new edition. The Second Folio (fig. 31) was printed by Thomas Coates (both the Jaggards were by then dead) for a consortium of publishers. Only William Aspley and John Smethwick were still alive from the group that had published the First, and they joined with several others to organize and finance the new edition.

The Second Folio is essentially a line-by-line reprint of the First, which would have saved time and money in the process of composition, though the pages of the First Folio were carefully read, almost certainly in the printing house itself. Over 1700 new readings were introduced, though none suggests access to material that would give them any particular authority. Almost all the changes are either corrections of typographical errors or modernizations of the language, changing spelling and punctuation in accord with contemporary linguistic practices. ("Who" and "whom," for example, are usually regularized in accord with the more rigorous grammatical expectations of the 1630s.) And efforts were made to rectify words or phrases where the First Folio readings were manifestly corrupt, correcting, for example, the First Folio's designation of the decisive battle in *Antony and Cleopatra* as "Action" to the proper "Actium" and the "miseries of Hecate" in Macbeth to the witch's "mysteries."

In other places, however, they get it wrong. Macbeth's "weird sisters," as modern editions have it, are in the First Folio the "wayward sisters" (or sometimes the "weyard sisters"), but rather than properly modernizing this, Macbeth at 3.4.14 sets out to find "the wizard Sisters."

While the Second Folio is not a scholarly edition, it is of course still of great significance, confirming the continued importance of Shakespeare, and establishing a principle that survives today among publishers: that Shakespeare is our contemporary and that the spelling, punctuation, and grammar of the text should declare this. The publishers of the Second Folio wanted a Shakespeare who could bridge the temporal gap that was opening up between his writing and his readers, and they created him. Nonetheless, though the volume deliberately sets out to make Shakespeare seem modern, the process did not apparently add much to the appeal of the book, and more than thirty years would pass before another edition would seem worth attempting.

There are various reasons for this, but the most obvious is that Shakespeare, in whatever spellings, seemed dated. Beaumont and Fletcher, the collaborative team that replaced Shakespeare as the main provider of plays for the King's Men, dominated both the stage and the bookstalls. Between 1640 and 1660, seventeen quartos of their plays reached print, and in 1647 a large folio volume was published with thirty-four others never before printed. In 1652, Peter Heylyn assessed the state of English letters and enthusiastically praised them as "not inferiour unto *Terence* and *Plautus*," while also commending Ben Jonson as the "equall to any of the ancients." But not a word of Shakespeare. The same year a group of publishers proposed, if there were sufficient demand, "to bring Ben Johnson's two volumes into one, and publish them in this form; and also to reprint old Shakespear." The adjective tells its own unexpected story.

Shakespeare was remembered, but remembered as he was, as a playwright of an earlier period. Editorial modernization did not make him timeless, seemingly refuting Jonson's famous claim that Shakespeare was "not of an age but for all time." In 1661, the diarist John Evelyn could say, to us incredibly, of *Hamlet* that "the old playe began to disgust this refined age." But by 1663, there was nonetheless enough demand finally to republish "old Shakespeare" and his "old" plays, and the Third Folio appeared in print. Quickly this was reissued in an augmented form, probably to spur lagging sales. This new version boasts that "unto this impression is added seven Playes, never before Printed in Folio. viz. *Pericles*, Prince of *Tyre*. The *London Prodigall*. The History of *Thomas* L[d]. *Cromwell*. Sir *John Oldcastle* Lord *Cobham*. The *Puritan Widow*. A *York-shire* Tragedy. [and] The Tragedy of *Locrine*" (fig. 32).

More Shakespeare, even if old Shakespeare, is better than less. This reissued edition of the Third Folio is more complete than any that came before. And this new, more complete Shakespeare was what was republished in 1685 in the Fourth Folio, and indeed again in 1709 when Rowe published his six-volume edition of the plays. But of the belatedly added plays only *Pericles* has made its way into the canon. The others have become part of an "apocrypha," as it has become known; they are the non-canonical plays, ones *not* written by Shakespeare. But it is not clear how anyone could have known this in 1664 or 1685 or even 1709. *The London Prodigal* had been published in 1605 as "By *William Shakespeare*"; *The History of Thomas Lord Cromwell* was published in 1602 as "Written by W. S."; *Sir John Old-castle* was published in 1619 (though with a title page dated 1600) and claiming it was "written by William Shakespeare"; *The Puritan Widow* was published in 1607 and claims to have been written by W. S.; *A Yorkshire Tragedie* was published in 1608 as "Written by W. Shakespeare"; and *The Tragedy of Locrine* was published in 1595 as "By W. S." All of the added plays had been plausibly identified on their early title pages as by Shakespeare. It would have been an irresponsible publisher who wouldn't have wanted to complete his "complete" Shakespeare, especially as a spur to sales.

The Bodleian Library at Oxford University certainly thought so. They had acquired a First Folio in 1624 and had it finely bound, but then they sold the volume forty years later once the reissued Third Folio was available. De-accessioned as one of a group of "superfluous library books sold by order of the curators" (as the Library records say), the Bodleian First Folio was purchased by an Oxford bookseller for £24. In 1906 the Bodleian repurchased its own First Folio with money raised by public subscription. From our perspective it seems incredible that the First Folio could ever have been thought superfluous, but in 1664 it could be — and indeed was. For those who were remembering Shakespeare then, the Third Folio was the better book, remembering Shakespeare in what seemed to be a better way.

32

The second impression of the Third Folio, with a list of "seven playes, never before printed in folio." *Mr. William Shakespear's Comedies, Histories, and Tragedies. Published according to the true Original Copies* (London, 1664). Beinecke Library, Yale University

# Mr. WILLIAM SHAKESPEAR'S

Comedies, Histories, and Tragedies.

Published according to the true Original Copies.

*The third Impression.*

And unto this Impression is added seven Playes, never before Printed in Folio.

*viz.*

*Pericles* Prince of *Tyre*.
The *London Prodigall*.
The History of *Thomas* L<sup>d</sup> *Cromwell*.
Sir *John Oldcastle* Lord *Cobham*.
The *Puritan Widow*.
A *York-shire* Tragedy.
The Tragedy of *Locrine*.

LONDON, Printed for P. C. 1664.

# TROILUS
## AND
# CRESSIDA,
OR,
*TRUTH* Found too Late.

A
# TRAGEDY
As it is Acted at the
## Dukes Theatre.

To which is Prefix'd, A Preface Containing the Grounds of Criticism in Tragedy.

Written By *JOHN DRYDEN* Servant to his Majesty.

*Rectius, Iliacum carmen deducis in actus,*
*Quam si proferres ignota indictaque primus,* Hor.

London, Printed for *Jacob Tonson* at the *Judges-Head* in Chancery-lane near *Fleet-street*, and *Abel Swall*, at the Unicorn at the West-end of S. *Pauls*, 1679.

## IV  *Shakespeare Improved*

By the end of the seventeenth century, Shakespeare's plays were still valued, but more as the progenitors of an English literary culture than as their finest example. In 1699, one contemporary called Shakespeare the "*Proto-Dramatist of England,*" even while noting the superiority of both Beaumont and Fletcher and Ben Jonson. To keep Shakespeare alive on the stage demanded more than just the regularizing of his spelling and grammar, and the dramatists of the late seventeenth and early eighteenth centuries began aggressively to modify his plays. The theaters, which had been officially re-opened only in 1660 after an eighteen-year hiatus while they had remained shut by order of Parliament, attracted a newly fashionable audience, less demotic than that which had filled Shakespeare's Globe, and Shakespeare's plays were adapted to suit their more refined aesthetic expectations.

Even as the Third and Fourth Folios were published in 1663 and 1685, Shakespeare was thought to be an anachronism on stage, a dramatist always praised but one who needed to be updated to satisfy the sensibilities of the new age. His plays still filled a major place in the repertory but almost always in versions that were drastically reshaped, through cuts and additions designed to simplify their logic and with songs and spectacle added to amplify their appeal. Thus the title page of John Dryden's revision of *Troilus and Cressida* in 1679 (fig. 33) announces it as his own composition; his preface, however, says that it is an adaptation designed to honor "the admirable Genius of the Author," even if to do so Dryden "remodel'd the plot," even "threw out many unnecessary characters," and modernized the language to bring Shakespeare's "English closer to our times." Though Dryden would say in the revision of *The Tempest* (undertaken with William D'Avenant) that "*Shakespear's power is sacred as a King's*" (fig. 34), his power was not so absolute that words could not be changed, scenes cut, even characters introduced, as "a Man who had never seen a Woman" is added to complement Shakespeare's unsophisticated Miranda, so that "two characters of Innocence and Love might the more illustrate and commend the other." And, as often as not, stunning theatrical effects were as important as the spoken language. A property bill for the weekly schedule at the Duke's Theatre lists among the expenses three shillings "For y^e Shour [i.e., shower] of Fire" (fig. 35).

"Newmodelling" indeed became the order of the day. Nahum Tate's 1681 *King Lear* (fig. 36) goes so far as to erase Shakespeare's tragic ending, allowing

33
John Dryden, *Troilus And Cressida, Or, Truth Found too Late. A Tragedy As it is Acted at the Dukes Theatre. To which is Prefix'd, A Preface Containing the Grounds of Criticism in Tragedy. Written by John Dryden* (London, 1679). Beinecke Library, Yale University

34

John Dryden, *The Tempest, Or The Enchanted Island. A Comedy. As it is now Acted at His Highness the Duke of York's Theatre* (London, 1670). Beinecke Library, Yale University

35

A manuscript property bill for the week of 19 November, bound in *The Tragedy Of Hamlet, Prince of Denmark. As it is now Acted at His Highness the Duke of York's Theatre* (London, 1676). Beinecke Library, Yale University

## Prologue to the Tempest, or the Enchanted Isle.

As when a Tree's cut down, the secret Root
   Lives under ground, and thence new Branches shoot;
So, from old Shakespear's honour'd dust, this day
Springs up and buds a new reviving Play.
Shakespear, who (taught by none) did first impart
To Fletcher Wit, to labouring Johnson Art.
He, Monarch-like, gave those his Subjects Law,
And is that Nature which they paint and draw.
Fletcher reach'd that which on his heights did grow,
Whilst Johnson crept and gather'd all below.
This did his Love, and this his Mirth digest:
One imitates him most, the other best.
If they have since out-writ all other Men,
'Tis with the drops which fell from Shakespear's Pen.
The Storm which vanish'd on the neighb'ring shore,
Was taught by Shakespear's Tempest first to roar.
That Innocence and Beauty which did smile
In Fletcher, grew on this Enchanted Isle.
But Shakespear's Magick could not copy'd be,
Within that Circle none durst walk but he.
I must confess 'twas bold, nor would you now
That liberty to vulgar Wits allow,
Which works by Magick supernatural things:
But Shakespear's pow'r is Sacred as a King's,
Those Legends from old Priesthood were receiv'd,
And he then writ, as people then believ'd.
But, if for Shakespear we your grace implore,
We for our Theatre shall want it more:
Who by our dearth of youths are forc'd t' employ
One of our Women to present a Boy.
And that's a transformation, you will say,
Exceeding all the Magick in the Play.
Let none expect in the last Act to find,
Her Sex transform'd from Man to Woman-kind.
What e're she was before the Play began,
All you shall see of her is perfect Man.
Or if your fancy will be farther led
To find her Woman, it must be a-bed.

Dramatis

Property Bill, Saturday Nov.r y.e 19th

| | | |
|---|---|---|
| Saturday Hamlet | A Baskett of Flowers for Mrs Mountfort | 0 : 0 : 3 |
| | A Baskett of Garden Mould for y.e Grave | 0 : 0 : 6 |
| Monday Double Gallant | p.d y.e Hire of A Monkey | 0 : 2 : 6 |
| | p.d y.e Use of A Tea Cannister | 0 : 0 : 3 |
| | For Two Cordiall Bottles | 0 : 0 : 3 |
| Tuesday Maids Tragedy | The Use of A Quentity of Lace for y.e Bed | 0 : 2 : 0 |
| | A p.r fine holland Sheets, & Pillowbiers | 0 : 1 : 6 |
| | The Use of Two Blanchetts | 0 : 1 : 0 |
| | Resons & Almonds, as Before | 0 : 0 : 9 |
| Wednesday Wanton Wife & New Farce | The Use of A Large Glass Lanthorn | 0 : 0 : 6 |
| | The Printed Song for Mrs Willis | 0 : 0 : 2 |
| | A Paper of Vermilion for y.e Stage | 0 : 0 : 2 |
| Friday Tempest | For y.e Shour of Fire | 0 : 3 : 0 |
| | Lightning | 0 : 0 : 6 |
| | For White Wans | 0 : 0 : 2 |
| | | 0 : 13 : 6 |

Thirteen shill.s & sixpence

Cibber
R. Wilks
B. Booth

36

*The History Of King Lear. Acted at the Duke's Theatre. Reviv'd with Alterations. By N. Tate* (London, 1681). Beinecke Library, Yale University

37

The title page of William D'Avenant's *Macbeth, A Tragædy* (London, 1674). Beinecke Library, Yale University

38

The earliest known manuscript of *Macbeth*, this seventeenth-century copy closely follows William D'Avenant's edition of 1674. Beinecke Library, Yale University

39

George Granville, *The Jew of Venice. A Comedy. As it is Acted at the Theatre in Little-Lincolns-Inn-Fields, by His Majesty's Servants* (London, 1701). Beinecke Library, Yale University

Cordelia not only to live and marry Edgar (in Shakespeare's play, not only is Cordelia dead, but the two characters never even speak), but Lear himself to survive and anticipate being "Cheer'd with relation of the prosperous reign / Of this celestial pair." Tate admits that he was "Rackt with no small Fears for so bold a change," but audiences received it enthusiastically, and it was more or less in Tate's version that *King Lear* was acted for the next 150 years. Even *Romeo and Juliet* was revised to provide the lovers a happy ending, though in this case, the new-modeled version and Shakespeare's original were "Playd Alternatively, Tragical one Day, and Tragicomical another," as John Downes, who had been the prompter at the Duke's Theatre, remembered in his *Roscius Anglicanus* (1708), a history of the Restoration stage.

Macbeth was still permitted to die in his defiance, but the play itself was revised heavily by D'Avenant, turning Shakespeare's stark tragedy into a theatrical spectacle with songs and dances, and with special effects allowing the witches to fly in from the wings. The printed edition of 1674 proudly advertises a text "with all the ALTERATIONS, AMENDMENTS, ADDITIONS, AND NEW SONGS" (fig. 37). *Macbeth* becomes almost operatic in D'Avenant's version, its heightened moral clarity focusing on Macbeth's "vain … Ambition," even as its elaborate choruses and dance routines ameliorated the play's tragic power. *Macbeth,* the musical, delighted Samuel Pepys on April 19, 1667 as "one of the best plays for a stage, and variety of dancing and music, that ever I saw."

Verbally, it is less impressive. Macbeth's "Come seeling night. / Scarf up the tender eye of pitiful day" is simplified by D'Avenant both in language and thought: "Come dismal Night. / Close up the Eye of the quick sighted day." And where Shakespeare's Lady Macbeth edgily urges her husband to "Look like the time," D'Avenant's more banally urges her husband to "Be cheerful, sir." The Yale manuscript (fig. 38) seems to have been directly from D'Avenant's alteration of the First Folio text, and serving perhaps as the copy from which the promptbook for his spectacular version of *Macbeth* was prepared. Like Tate's revision of *King Lear,* D'Avenant's *Macbeth* was successful on stage, regularly played, to the exclusion of Shakespeare's, into the middle of the eighteenth century.

In the theater, then, "Old Shakespear" was usually remembered by making him new, and Shakespeare "new-modelled" was slow to yield to its original any place in the theater. Adapted versions of many plays, including *Richard III, Henry V, Taming of the Shrew, Timon of Athens, Coriolanus, Antony and Cleopatra,* and *Cymbeline,* appeared and stubbornly held the stage for decades. Some printed versions, however, revealed the adaptor's anxiety. George Granville's *The Jew of Venice,* for example, confidently revises Shakespeare's *Merchant,* but in the published edition of 1701 he promises to indicate with quotation marks the lines that are his own in order that "nothing may be imputed to *Shakespear* which may seem unworthy of him." "Old Shakespear" still exerts his power, and the printed page of Granville's play registers it clearly (fig. 39).

38

39

p. 2073.

# ROMEO
# AND
# JULIET.
# A
# TRAGEDY.

Printed in the YEAR 1709.

## V  *Shakespeare Restored*

There were, however, better ways to acknowledge Shakespeare's excellence than by typographically distinguishing his work from the alterations designed to satisfy contemporary theatrical taste. Plays, it was assumed, would be adapted for stage, but printed plays might well strive to restore their author's words to the page. Though individual plays were often printed, as in the case, say, of the Dryden-D'Avenant *Tempest,* "as it is now acted at His Highness the Duke of *York's* THEATRE," the age also demanded texts that attempted to recover what the Shakespearean scholar, Lewis Theobald, called the "genuine Text." As playwrights tried to make Shakespeare contemporary on stage by radical acts of alteration, a series of scholars pursued what Theobald called their "Hopes of restoring to the Publick their greatest Poet in his Original Purity."

But it was immediately clear that these hopes would not be easily realized. Nicolas Rowe, the first of the eighteenth-century editors, was commissioned by the London publisher Jacob Tonson to undertake a new edition to replace the Fourth Folio, which had been published in 1685. Rowe's complete Shakespeare appeared in 1709, no longer in a single large folio volume but in "a very neat and correct edition of Mr. William Shakespeare's work in six volumes in octavo and adorned with cuts," as it was advertised in *The London Gazette*. In truth it was more "neat" than it was "correct," as even Rowe was willing to acknowledge.

It was certainly easier to read than the oversized Folios, simpler to handle and offering a reader more guidance, providing a "Life" of Shakespeare, introducing act and scene divisions in all the plays, providing lists of characters arranged by rank and gender, and specifying locations for the action. The "cuts," handsome engravings introducing each play, give a sense of contemporary theatrical practice rather than that of Shakespeare's own time (fig. 40). But the text makes little headway toward the recovery of the "Original Purity" of Shakespeare's own. "I must not pretend," Rowe admitted, "to have restor'd this Work to the Exactness of the Author's Original Manuscripts. Those are lost, or, at least are gone beyond any Inquiry I could make; so that there was nothing left, but to compare the several editions, and give the true Reading as well as I could from thence." Rowe, in fact, compared somewhat fewer editions than his preface lets on, basing his work almost entirely on the 1685 Fourth Folio, though he did look at a few of the earlier quartos, finding and including, for example, the prologue to *Romeo and Juliet,* which none of the Folios prints, though oddly placing it at the end of the play.

*40*
"Romeo and Juliet," in Rowe's edition of 1709. Beinecke Library, Yale University

But Rowe's two-fold recognition—that Shakespeare's manuscripts have not survived and that the authority of the Folio is not absolute—established the difficult conditions for editing Shakespeare that still pertain today. Still, the limits of his edition were almost immediately obvious, and in 1721 announcement was made that "the celebrated Mr. Pope is preparing a correct Edition of Shakespear's works; that of the late Mr. Rowe being very faulty." Alexander Pope, already famous for poems like "The Rape of the Lock" and for translations of both the *Odyssey* and the *Iliad*, eagerly accepted the commission from Tonson to replace Rowe's edition. Pope began by conscientiously seeking out and examining the early printings of Shakespeare, eventually seeing editions of all of the plays by Shakespeare that had been in print before the 1623 Folio, with the single exception of *Much Ado About Nothing*. But his research only left him believing that "It is impossible to repair the Injuries already done him, too much time has elaps'd and the materials are too few." Scholarly despair, however, gave way to critical self-confidence, and his edition distinguishes itself mainly by the marking of what he called "the most shining passages" with commas in the margins, and by identifying "suspected passages, which are excessively bad," which are then removed from the text and "degraded to the bottom of the page."

Throughout the century, publishers continued to commission editors, one after another, to replace the most recent edition, each time insisting on the total inadequacy of the last and the incomparable virtues of the replacement, though inevitably the new editor based his edition on that which was to be replaced. Lewis Theobald was next in the Tonson line, and his edition of 1733 indeed was prepared from the second edition (1728) of Pope's Shakespeare. Theobald, however, understood more about the early printed texts than either Rowe or Pope and more conscientiously collated them; he also discussed editorial issues with others who were interested in the problems they posed, notably Styan Thirlby, a brilliant polymath, who had from his undergraduate days at Jesus College, Cambridge been interested in the texts of Shakespeare. Thirlby gave Theobald the "Liberty of collating his Copy of Shakespeare, mark'd thro' in the Margin with his own Manuscript References and accurate Observations," the copy now residing at Yale (fig. 41).

Pope would famously belittle Theobald in his *Dunciad* as "king" of the dunces, stung by Theobald's *Shakespeare restored, or, A specimen of the many errors, as well committed, as unamended, by Mr. Pope : in his late edition of this poet. Designed not only to correct the said edition, but to restore the true reading of Shakespeare in all the editions ever yet published*. Theobald did not always restore "the true reading" in his edition, though his criticisms of Pope are just. Much of his own editorial

work is sound, and many of his emendations have been accepted, perhaps most famously in Mistress Quickly's narration of the death of Falstaff where she reports, "'a babbled of green fields," making moving sense of the Folio's "A table of green fields," and displaying knowledge both of Shakespeare's idiom (where 'a often means "he") and of early writing habits (which might easily lead to confusion of "b" and "t").

Subsequent editors continued working in this manner, ostensibly in competition with but in fact building upon the labors of those who had come before: Hamner, Warburton, Johnson, Capell, Steevens, Reed, Malone, and Boswell. "Not one has left Shakespeare without improvement," graciously remarked Johnson of his predecessors, but none before or after has fully succeeded in the goal first defined: to restore Shakespeare to his "Original Purity." Warburton would boldly claim in 1747 that with his edition "The Genuine Text (collated with all the former Editions, and then corrected and emended) is here settled," but the continued activity of editors into our present and no doubt beyond shows the lie. There is no way to recover "The Genuine Text." It isn't even exactly clear what that might mean, since Shakespeare wrote his plays for a theater in which he knew they would change as they were readied for performance and as they were performed, their very instability the compelling proof of their vitality over time.

41
Styan Thirlby's annotated copy of *The Works of Shakespear. In Six Volumes. Collated and Corrected by the former Editions, By Mr. Pope* (London, 1725). Beinecke Library, Yale University

OF WINDSOR.

*Simp.* Marry, sir, [3] the Pitty-wary, the Park-ward, every way; old Windsor way, and every way but the town way.

*Eva.* I most fehemently desire you, you will also look that way.

*Sim.* I will, sir.

*Eva.* 'Pless my soul! how full of cholers I am, and trempling of mind!—I shall be glad, if he have deceiv'd me: how melancholies I am!—I will knog his urinals about his knave's costard, when I have good opportunities for the 'ork:—'pless my soul!

[*Sings.*

[4] *By shallow rivers, to whose falls*
*Melodious birds sing madrigals;*
*There will we make our peds of roses,*
*And a thousand vragrant posies.*
    *By shallow*——

*Mercy*

[3] ——*the Pitty-wary,*——] The old editions read, the *Pittie-ward*, the modern editors the *Pitty-wary*. There is now no place that answers to either name at Windsor. The author might possibly have written the *City-ward*, i. e. towards London. *Petty-ward* might, however, signify some small district in the town which is now forgotten. STEEVENS.

[4] *By shallow rivers,* &c.] This is part of a beautiful little poem of the author's; which poem, and the answer to it, the reader will not be displeased to find here.

### The Passionate Shepherd to his Love.

Come live with me, and be my love,
And we will all the pleasures prove
That hills and vallies, dale and field,
And all the craggy mountains yield.
There will we sit upon the rocks,
And see the shepherds feed their flocks,
By shallow rivers, by whose falls
Melodious birds sing madrigals:
There will I make thee beds of roses
With a thousand fragrant posies,
A cap of flowers, and a kirtle
Imbroider'd all with leaves of myrtle;

U 4                                A gown

*[Marginal manuscript note:] I think ye reading of the old Editions must be right. To all the other words in ye sentence ward or way is added in the sense of toward why not then to ye. What can wary mean here? If we do not read ward why not way, wch differs from ye inexplicable word wary only by a letter? I cannot at any rate conceive how ward should mean district as Mr. St: supposes. I have looked says Simple in answer to Parson Hugh's question, towards ye Park, towards ye Pitty, towards old windsor everyway but ye town way. What ye Pitty or Pitty was, is another question. There is no place at or near Windsor now called by either of those names—but there might be in Shakespeare's time. In short Pitty-ward or Pitty-ward has a meaning though we may not be able clearly to explain it—but Pitty-wary seems absolutely irreconcileable with ye rest of ye sentence, & not capable of any explanation.*

# VI  *Shakespeare Deified, Forged, Denied*

If the genuine Shakespearean text eluded editors, the passion with which it was sought and interpreted tells its own story. Theobald never doubted the value of the intense editorial labor devoted to Shakespeare, since he "stands, or at least ought to stand, in the nature of a classic Writer." And indeed editions, with their careful comparisons of variant texts and their increasingly elaborate annotations (fig. 42), lavish the sort of scholarly attention normally reserved for a classical writer like Virgil. But even this noble comparison would prove inadequate. Dryden was perhaps the first to raise even those stakes, calling him the "divine Shakespeare," the adjective functioning not in its ameliorated sense of merely "excellent," but somehow claiming for the playwright a creative power exceeded only by God. The actor-playwright from middle-class roots in the English midlands, whose earliest writing was praised as "sweet" or "ingenious," becomes by the middle of eighteenth century, "Godlike" and "immortal." Shakespeare himself becomes, as Arthur Murphy wrote in 1753, a "kind of secular religion," and his works what Murphy called, "a lay bible." Stratford-upon-Avon becomes not merely a tourist destination but virtually a pilgrimage site, with splinters of a mulberry tree putatively planted by Shakespeare sold (profitably) as relics.

"SHAKESPEARE! SHAKESPEARE! SHAKESPEARE!" wrote the great actor David Garrick, the mere reiteration of Shakespeare's name serving as the most appropriate motto for the Shakespeare Jubilee held in Stratford-upon-Avon in September 1769 and marked by the dedication of the new town hall and a statue of the town's most famous citizen. Accompanied by a choir and orchestra from the Drury Lane Theatre in London, Garrick stood atop a temporary rotunda alongside the river Avon to speak his *Ode upon dedicating a building, and erecting a statue, to Shakespeare* (fig. 43). What justified the extravagance was obvious to all: "'Tis he! 'Tis he! That demi-god.... To him the song, the Edifice we raise, He merits all our wonder, all our praise!" Shakespeare became unembarrassedly "the God of our idolatry," and Garrick himself, as William Cowper would say, "great Shakespeare's priest."

At least Garrick was unembarrassed. Others were less comfortable with the mix of idolatry ("bardolatry" was the witty portmanteau term for the attitude later coined by George Bernard Shaw) and opportunism. The celebration of Shakespeare was also a celebration of Garrick (as well as a much-needed financial lifeline lasting to the present for the sleepy market town of Stratford), and the fact did not escape notice. "O for the genius of Dean Swift," wrote the

*42*
A reader's notes on the annotated Shakespeare of Samuel Johnson and George Steevens, ed., *The Plays of William Shakespeare* (London, 1778). Beinecke Library, Yale University

43

*Mr. Garrick reciting the Ode in honor of Shakespeare at the Jubilee at Stratford, with the Musical Performers* [London, 1769]. The Lewis Walpole Library, Yale University

44

*Continuation of the Procession of Shakespear's Characters* [London, 1769]. The Lewis Walpole Library, Yale University

satirical author of *Garrick's Vagary, or England run mad* (London, 1769), commenting on the proceedings: "What Devil from Hell possesses ye all?"

Still Garrick's sense of Shakespeare's unrivaled genius became a truism for the nation. "We ne'er shall look upon his like again!" proclaimed the tickets for the Jubilee, cribbing from Hamlet's mourning for his dead father. And yet even this excerpt, like so many of Garrick's own performances of Shakespeare for audiences in the Drury Lane Theatre in London, was not quite an accurate rendering of Shakespeare's text, which was again (and again) reshaped for purposes that were not his own. But the Jubilee's extraordinary act of remembering Shakespeare ensured that he could never be forgotten even by those who had neither read nor heard a word he had written. The Jubilee itself did not remedy this as no plays were performed, and even the procession of notable characters (frontispiece; and fig. 44) that was planned had to be cancelled on account of the sheets of rain that fell. Shakespeare was, however, embedded in the consciousness of the nation as an object of veneration, ironically, as the plays themselves were removed from the popular culture in which they were originally nourished, to be sequestered in the playhouses and in the studies of a social and scholarly elite.

Scholars sought more evidence about his life and works, and tourists purchased more remembrances and relics of his past. In 1794, a cache of documents came to light which offered to solve many of the mysteries that surrounded the life of England's "demi-god," including his own handwritten "Profession of Faith," a letter to his wife-to-be Anne Hathaway ("Anna

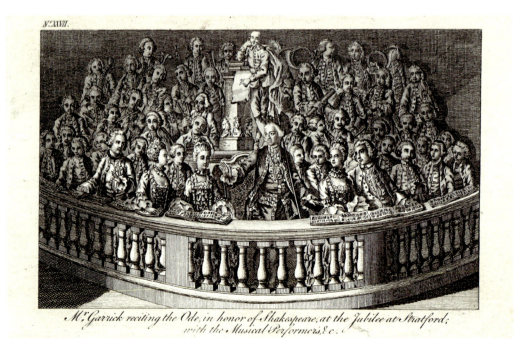

43

Hatherrewaye"), a catalogue of Shakespeare's library, a deed appointing his actor friend John Heminge executor of his estate, specifying that should his plays be again republished they be so from his "true writtenn Playes" rather than published "from those now printed," and even a letter from Queen Elizabeth expressing her thanks for the "prettye Verses" he had sent her. The following year, continued searching turned up a manuscript of *King Lear* and a "small fragment" of *Hamlet* (*Hamblette*). The papers were publicly displayed and then published later in 1795 (dated 1796) in a large volume entitled *Miscellaneous Papers and Legal Instruments under the Hand and Seal of William Shakespeare* (fig. 45), and soon news circulated that even more papers existed, including manuscripts of *Julius Caesar, Richard II*, and two hither-to unknown plays: *Henry II* and *Vortigern*.

Understandably the new discoveries created a furor of excitement. "How happy am I to have lived to the present day of discovery of this glorious treasure," wrote James Boswell, the friend and biographer of Samuel Johnson. "I shall now go to my grave in peace." And though sadly soon he would indeed go to his grave, quickly he must have been turning over in it. Everything was a forgery.

William Henry Ireland, the nineteen-year-old son of an engraver and art and antique dealer, had faked it all, beginning with a forged mortgage agreement between Shakespeare and Heminge, which he had written on a piece of old parchment he had taken from the records of the law office in which he worked. In a sense it is amazing how much the young Ireland knew in

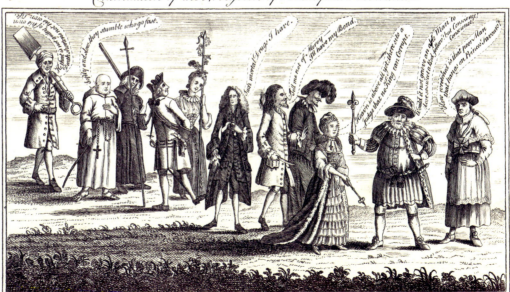

44

45
A "likeness of Shakespeare," one of many documents forged by William Henry Ireland. Ireland, *Miscellaneous Papers and Legal Instruments under the Hand and Seal of William Shakespeare* (London, 1796). Beinecke Library, Yale University

order to forge so much and convince so many. But all too quickly the fraud was revealed. On 31 March 1796, Shakespearean scholar Edmond Malone published an exhaustive study of the documents, *An Inquiry into the Authenticity of Certain Miscellaneous Papers and Legal Instruments,* declaring them fakes. Although Ireland mounted an impassioned defense, Malone's evidence was irrefutable, and Ireland eventually confessed the forgery.

What is perhaps most significant about this odd episode is not that it was attempted but that so many educated people were taken in by it. Once exposed, it seemed an obvious enough fake: the use of words not yet in use, reference to the Globe Theatre before it was built, and signatures that didn't correspond at all to known examples (leading Ireland to claim, for example, that there were two actors named John Heminge). But the desire for information about Shakespeare made people eager to believe, especially information that showed him intimate with aristocrats, even royalty.

The known biography of the middle-class man from the English midlands, who had come to London as an actor, seemed for many inadequate to explain the genius of England's "demi-god." Ireland sought to fill these gaps with his own inventions (nor would he be the last to do so); others would take another tack: suggesting that someone other than Shakespeare wrote the plays. Though when, in 1759, a character in the popular farce *High Life Below the Stairs* would respond to the suggestion that she read Shakespeare by asking "who wrote it," the joke is not (yet) that Shakespeare didn't; it is that she thinks "Shakespeare" is the name of a book, not of an author. But in a sense she is right, and many have come to think of "Shakespeare" as the name of a book, and sometimes a book written by someone else, someone more obviously fit to provide England's "lay bible." Since the early nineteenth century, thousands of articles and books have been written arguing against Shakespeare's authorship of the poems and plays, many by respected writers and thinkers convinced that "the man from Stratford" was incapable of it. "I can think of little else," writes James Shapiro, "that unites Henry James and Malcolm X, Sigmund Freud and Charlie Chaplin, Helen Keller and Orson Welles, or Mark Twain and Sir Derek Jacobi."

In 1857, Delia Bacon, a former teacher then living in New Haven, published her *Philosophy of the Plays of Shakespeare Unfolded* (fig. 46). She was a woman of intellectual talent and sophistication, a friend of Hawthorne, Emerson, and Samuel Morse, and she had been researching for about a dozen years her conviction that the plays were not written by Shakespeare but by a group of more socially distinguished men, including Francis Bacon, Walter Raleigh, and the Earl of Oxford, collaborating to produce plays that were designed to expose the tyranny of the Elizabethan and Jacobean courts. Counterevidence

was taken as proof: when asked about Ben Jonson's praise of Shakespeare, she replied that she "knew all about Ben Jonson.... He had two patrons..... One was Raleigh, the other was Bacon." For her, the evidence was clear: Shakespeare was a "stupid, illiterate, third-rate play actor," and the plays could only have been written by someone (or ones) with "the highest Elizabethan breeding, the very loftiest tone of that peculiar court culture."

Though other "anti-Stratfordians," as those who doubt Shakespeare's authorship are sometimes called, would propose candidates different from Delia Bacon's sometimes shifting list of collaborators, almost all make the same argument. The actor Shakespeare would not have known or experienced enough to write the plays. And to Francis Bacon, Raleigh, and the Earl of Oxford other names have been added, including Christopher Marlowe, the Earl of Rutland, Henry Neville, John Florio, even Queen Elizabeth and King James. The very multiplicity of candidates may itself argue against the claims of any one, but in any case it tells of the continuing desire to remember and understand Shakespeare, whoever he may be.

46
Letter from Nathaniel Hawthorne to Delia Bacon, Liverpool, England, 6 October 1856. Beinecke Library, Yale University

# 15th Night of Mr. CHARLES KEAN IN 'HAMLET!'

On which occasion Privileges of every description (except those of the Public Press) will be suspended.

## Theatre Royal, Drury Lane.

This Evening, WEDNESDAY, February 21st, 1838,
Her Majesty's Servants will perform Shakspeare's Tragedy of

# HAMLET!

### WITH NEW SCENERY, DRESSES, & DECORATIONS.

Claudius, King of Denmark, Mr. BAKER,
Hamlet, .... .... .... Mr. CHARLES KEAN,
Polonius, Mr. DOWTON, Laertes, Mr. KING,
Horatio, Mr. H. COOKE, Rosencrantz, Mr. F. COOKE,
Guildenstern, Mr. DURUSET, Osrick, Mr. BRINDAL,
Marcellus, Mr. HONNER, Bernardo, Mr. HOWELL,
First Actor, Mr. M'IAN, Second Actor, Mr. T. MATTHEWS,
1st Grave-Digger, Mr. COMPTON, 2nd Grave-Digger, Mr. HUGHES
Ghost of Hamlet's Father, .... Mr. COOPER,
Gertrude, .... Mrs. TERNAN, Ophelia, .... Miss FORDE.

☞ *The following, amongst other Scenes, have been painted for this occasion by Messrs.* GRIEVE.
PLATFORM of the CASTLE. ANOTHER PART of the PLATFORM.
**THEATRE in the COURT of DENMARK**
THE QUEEN'S CLOSET. CHURCH-YARD in the Vicinity of THE PALACE.
**STATE APARTMENT IN THE PALACE.**

Previous to the Tragedy the Band will perform C. G. Reissiger's Overture to 'NERON,'

To conclude with (*First Time at Half-Price*) the Grand Historical Opera of

# Joan of Arc!

The Overture and the whole of the Music composed by M. W. BALFE.
Charles the Seventh, of France, .... .... Mr. BAKER,
Count Dunois, Mr. TEMPLETON, Beauvais, (*Enemy to the King*) Mr. FRAZER,
Theodore, .... (*a Young Vintager*) .... Mr. M. W. BALFE,
Renaud, (*Joan's Uncle*) Mr. GIUBILEI, Badet, (*his Nephew*) Mr. E. SEGUIN,
Baudricourt, (*Provost of Vancouleurs*) Mr. F. COOKE, John of Luxembourg, Mr. HARRIS,
Bertrand, (*a Gaoler*) Mr. HUGHES, Corporal Twist, Mr. S. JONES,
Joan of Arc, .... Miss ROMER, St. Catherine, .... Miss FORDE,
Agnes Sorel, Mrs. ANDERSON, Madelon, (*a Villager*) Miss POOLE,

*Monks*—Messrs. Atkins, Birt, Butler, Caulfield, Chant, Healy, M'Carthy, Miller, T. Jones, Price, Santry, Tett, S. Tett, Tolkien, Walsh, Witting, &c.
*Nuns*—Mesdames Allcroft, Boden, R. Boden, Butler, Connelly, Goodson, Goodwin, Mapleson, Perry, Smith, Walsh, &c.
*Peasants*—Mesdames Foster, Hall, Hatton, Lane, Reed, Thomasin, Beremitti, Bodman, Chester, Fenton, Hartley, Lee, Marsano, Miller, Panormo, Sutton, J. Sutton, Vials, &c.

## VII  *Shakespeare Disseminated*

Even if the identity of their author was called into question, Shakespeare's great characters—Hamlet, Iago, Lady Macbeth—continued to be loved and remembered. These and the celebrity actors who played them increasingly came to define Shakespeare's plays for audiences, just as they had in the procession of characters Garrick had created for the Jubilee in Stratford in 1769. The plays became star turns more than great works of literature. This advertisement (fig. 47) promotes Charles Kean's performance as Hamlet at the Theatre Royal on Drury Lane in 1838, a show that could be seen three times each week, with "new scenery, dresses, & decorations," and also with a musical overture and a "Grand Historical Opera" to conclude the evening. "Shakespeare's Tragedy" appears only in a tiny font on the playbill, as the luminous and multifarious theatrical event overwhelmed Shakespeare's play.

The very same viewers who flocked to the theaters to see its stars could, however, become themselves performers of Shakespearean scenes, enabled by the publication of play texts and song books, like this (fig. 48) published in 1815, in which Thomas Arne's "Thou soft flowing Avon, Written in Honor of Shakespear by Garrick" could be played alongside songs written for *Much Ado About Nothing* or *Measure for Measure*, "Arranged for the Piano Forte by Mr. Addison." The texts of Shakespeare were also encountered as theater souvenirs, dramatically illustrated with scenes from performances and, then as now, with portraits of famous actors in their roles. For the price of one shilling, souvenirs from performances of *King Henry the Eighth* and *King Lear* at the Lyceum Theatre, London, in January and November of 1892 offered glimpses of the actor Henry Irving, cloaked and bearded as Lear, or scenes of the court in Tudor London (figs. 49 and 50).

But the universal Shakespeare that was to emerge over the nineteenth century had less to do with individual performances and actors, and more with the technologies of mass production and the mass audiences these, in turn, produced. In 1860, Kean was himself involved with an edition of selections from Shakespeare's plays, "as arranged for representation at the Princess's theatre, and especially adapted for schools, private families, and young people," one in a series of school texts to be published over the nineteenth century, as Shakespeare entered the classroom. The wonderfully diminutive 1822 Pickering "Diamond" edition, a miniature set, bound into nine volumes, was an early example of the efflorescence through the mid-

*47*
The Theatre Royal's advertisement for the *15th night of Mr. Charles Kean in 'Hamlet!'* [London, 1838]. Beinecke Library, Yale University

48

*A collection of the vocal music in Shakespear's plays: including the whole of the songs, duetts, glees, choruses, &c. : engraved from original ms. & early printed copies* [London, 1815]. Beinecke Library, Yale University

49 & 50

Henry Irving, *Souvenir of Shakespeare's King Henry the Eighth, presented at the Lyceum Theatre … Jan 5 1892* and *Souvenir of King Lear, presented at the Lyceum Theatre … Nov: 10 1892* (London, 1892). Beinecke Library, Yale University

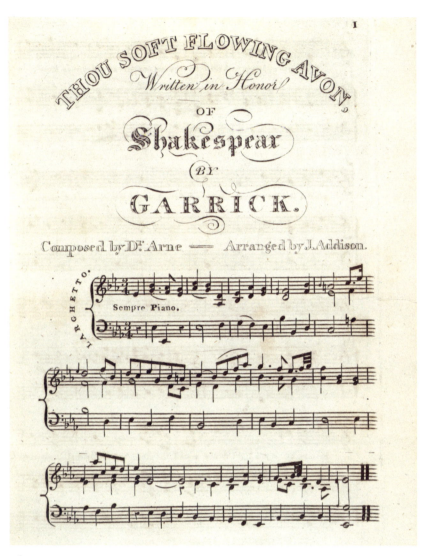

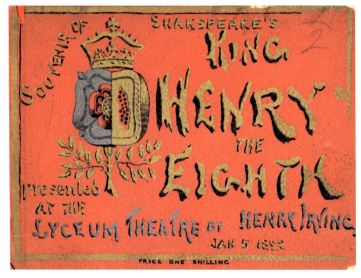

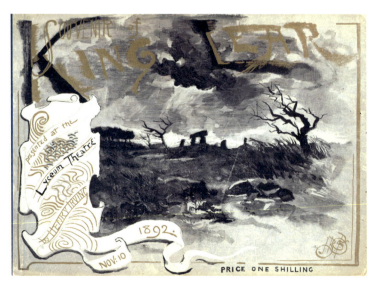

nineteenth century of popular editions in increasingly inexpensive format for a mass-market audience. The Pickering and other editions make visible the publishers' assumption that, if the works of Shakespeare could be made affordable for a popular audience, then they would be widely bought.

The printed Shakespeare that appeared in the nineteenth century was an industrial Shakespeare. The steam press, mechanical type-casting, woodpulp and other forms of cheap paper: these were the factors that made possible the entry of Shakespeare into an emerging popular marketplace in the inexpensive editions—the "shilling Shakespeares"—which began to appear in the mid-nineteenth century. In 1864, the Scottish publisher Alexander Macmillan proposed an affordable one-volume edition of the plays, the "Globe" Shakespeare, priced at three shillings and six pence (or about a half day's wage for a carpenter) and produced in an initial run of some twenty thousand copies, the first of several hundred thousand which the edition would eventually sell (fig. 51). Macmillan's "Globe" was only the first in a series of inexpensive editions, as London publishers raced to find the most popular, least expensive Shakespeare with which to dominate the market.

51
William George Clark and William Aldis Wright, eds., *The Globe Edition. The Works of William Shakespeare* (Cambridge and London, 1864). Beinecke Library, Yale University

# SPECIMEN OF
# PRESENTATION PLATE, GIVEN AWAY
## With No. 1 and Part I. of
# CASSELL'S ILLUSTRATED SHAKESPEARE.

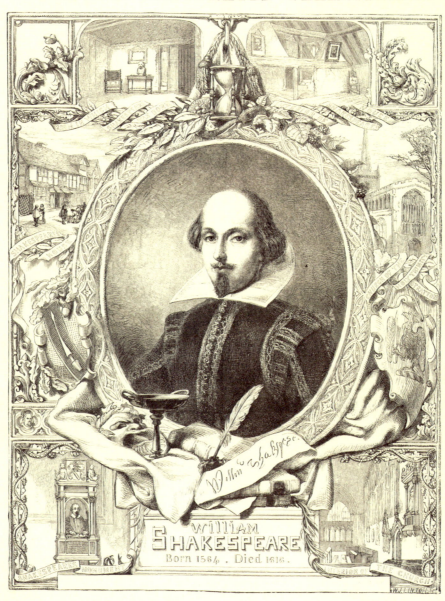

No. 1 Ready January 29; Price One Penny.
Part I. Ready February 27; Price Sixpence.

52

Petter & Galpin Cassell, *Specimen of presentation plate, given away with no. 1 and part 1 of Cassell's Illustrated Shakespeare* [London, 1863]. Beinecke Library, Yale University

53

"View of an Ancient Building in Henley Street, Stratford-on-Avon," in John Thompson, *Illustrations of Shakespeare* (London, 1826).

54

Scenes from "King Henry IV. Part I," in Thompson, *Illustrations of Shakespeare* (London, 1826). Beinecke Library, Yale University

The same technologies which allowed publishers to produce Shakespeare for a popular audience also opened the possibility of inexpensively produced illustrated editions. From 1709, with Rowe's edition, particular scenes and characters as they had been played on stage were remembered in the engravings that graced illustrated editions. By 1864, when Charles and Mary Cowden Clarke promoted their *Cassell's Illustrated Shakespeare*, the illustrations were taken as a necessary embellishment to the plays, one opening the "memory of the matchless Bard of Avon" to his audience as much as did the editors' explanatory notes to the text. From Rowe onwards, Shakespeare himself figured in the illustrated editions almost as prominently as the plays themselves. In this publisher's specimen (fig. 52), Shakespeare, his signature, and scenes from Stratford-upon-Avon and the memorial can be found, in a presentation plate "given away with No. 1 and Part I. of Cassell's Illustrated Shakespeare." Similar scenes introduce Thompson's *Illustrations of Shakespeare* (1826), with its bust of "Shakspeare" and "View of an Ancient Building in Henley Street, Stratford-on-Avon" (fig. 53). Recurring in illustration through the nineteenth century, Shakespeare himself was as visible an icon of a popular and patriotic English literary culture as those characters, like Falstaff and Prince Henry, who reappear in the illustrated sequences of Thompson's rendition of the plays (fig. 54).

But while Shakespearean characters did command the stage, could be seen in various kinds of illustrations, and were carried onto trains and into classrooms in cheap one-volume editions, they were not necessarily always welcome in the parlor of the English household. Falstaff, Romeo, Benedick: the blush-inducing antics of many of Shakespeare's characters were difficult to incorporate into family life, despite the acknowledged importance of

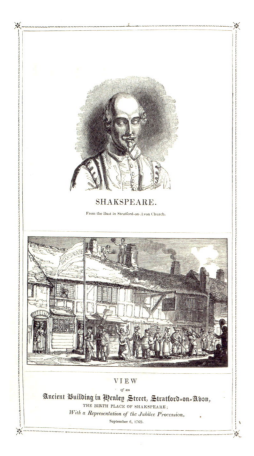

53

54

55

Lady Macbeth, in Anna Jameson, *The Characteristics of women, moral, poetical and historical: with fifty vignette etchings* (London, 1832). Beinecke Library, Yale University

56

"A Lover of Shakespeare," [England, n.d.]. Beinecke Library, Yale University

57

*Shakespeare's Home: visited and described by Washington Irving and F.W. Fairholt* (New York, 1877). Beinecke Library, Yale University

Shakespeare as an iconic national author. Into this breach stepped Henrietta Bowdler, who followed her career as a religious pamphleteer with an expurgated edition of those twenty of Shakespeare's plays deemed acceptable for public consumption, "in which nothing is added to the original text; but those words and expressions are omitted which cannot with propriety be read aloud in a family." *The Family Shakespeare,* first issued in 1807, was taken up in 1818 by Henrietta's brother, Thomas Bowdler, and published in at least twenty British and American editions through the nineteenth century. The poet Swinburne praised the effort, now so often derided: "No man ever did better service to Shakespeare than the man who made it possible to put him into the hands of intelligent and imaginative children."

With the text purified for family reading, authors like Charles and Mary Lamb, with their immensely popular *Tales from Shakespeare* (1831), and Anna Jameson, with her *Characteristics of women, moral, poetical, and historical* (1832), could further embed Shakespeare into the national memory, mining the possibilities of the plays for edification. Juliet, for instance, for all her pleasing capacity for affection, could be seen to demonstrate a "deficiency of reflection and of moral energy"—unlike Lady Macbeth, who, as Jameson remarks, is "so supremely wicked" and yet "so consistently feminine" (fig, 55). Shakespeare takes his place in the domestic sphere, as in this illustration of "A Lover of Shakespeare," in which a young woman with her octavo edition held comfortably in one hand sits in a room with a harp, embroidery table, sewing box, flowers, and enameled cabinet, gazing through the halo of her bonnet (fig. 56). At last, Shakespeare could be read everywhere, in every extremity of circumstance, even quietly alone in one's room.

Even in America. By 1877, when Washington Irving published his *Shakespeare's Home,* an illustrated tour of Stratford-upon-Avon, it was for an American audience, to whom the importance of such a pilgrimage to the Bard's haunts and homeland needed no justification (fig. 57). The first American edition of Shakespeare's works had been published long previously, in 1795, "Corrected from the latest and best London editions," with notes by Samuel Johnson and a "striking likeness from the collection of His Grace the Duke of Chandos." And Shakespeare had been remembered even in the early days of the Revolution: "Be taxt or not be taxt: that is the question." Emerson would call Shakespeare not merely the man who "wrote the text of modern life" but "the father of the man in America."

But Shakespeare, of course, was England's. The patriotic Shakespeare, as a trope by which to embody a particular version of an English national history, had long been present in British literature. Dugdale's *Antiquities of Warwickshire*

I DOUBT whether the epithet *historical* can properly apply to the character of Lady Macbeth; for though the subject of the play be taken from history, we never think of her with any reference to historical associations, as we do with regard to Constance, Volumnia, Katherine of Arragon, and others. I remember reading some critique, in

VOL. II.

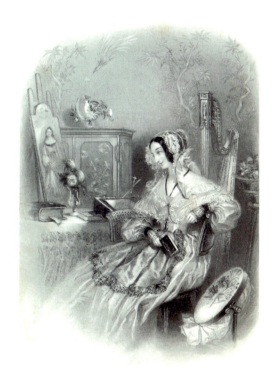

Drawn & Engraved by J. Storer.      SHAKSPEARE'S BIRTH PLACE.      for Cole's Residences of Actors
Stratford on Avon.

58

59

(1656) had set Shakespeare and Stratford within a consciously nationalistic tradition, thus initiating the process of turning Shakespeare into an icon of Englishness itself. If all the world (or at least all of England) were a stage, then Shakespeare's characters and scenes lent many of the accoutrements with which it was furnished, as familiar quotations and increasingly familiar illustrations became part of the material culture of the English household (figs. 58 and 59). Readers, particularly young readers, of Shakespeare were also exhorted to greatness by his example: in 1898, the *Boys' Own Paper*, the pious pedagogical organ of the "Leisure Hour" Office, issued its "A Day in Shakespeare's Country," describing the haunts of the boyhood Shakespeare and urging its readers by his example to excellence in their own right in their own times (fig. 60).

Shakespeare and his characters were also co-opted into daily political and social life. In 1803, the London printer Luke Hansard published a folio broadside entitled "Shakespeare's Ghost, our immortal bard who was as good an Englishman as a poet," a series of patriotic quotations from *Henry IV, part one* and other plays, followed by an exhortation to Britons to resist Napoleon in the event of a French invasion of England (fig. 61). And when, in 1886, Charles Dickens printed a commemorative piece, *November the nineteenth, 1861, 'The morn that I was wedded'*, it was in the form of a seating chart for the wedding supper, locating each guest with a particular Shakespearean quotation (fig. 62). It is peculiarly apt that Dickens, whose own characters would become features of English popular culture, should be found in the same act of appropriation which brought all things Shakespearean into the daily fabric of nineteenth-century English life. As Thomas Carlyle promised, in *On Heroes, Hero-Worship, and the Heroic in History* (1841): "A thousand years hence … From Paramatta, from New York, wheresoever English men and women are, they will say to one another, 'Yes, this Shakespeare is ours; we produced him, we speak and think by him; we are of one blood and kind with him.'"

*58 & 59*
Fan, with vignettes engraved by George Wilson. *Shakespeare's Seven Ages* (London, 1796). Beinecke Library, Yale University

(*Drawn for the "Boy's Own Paper" by* W. W. QUATREMAINE.)

1. The Clopton Bridge.  2. Shakespeare's birthplace.  3. The Grammar School where Shakespeare was educated, and Tower of the Old Guild Chapel.
4. Holy Trinity Church, where Shakespeare was buried.  5. Anne Hathaway's Cottage at Shotting.

60

*The Boy's Own Paper* (London, July 1893). Beinecke Library, Yale University

61

*Shakespeare's Ghost! Our immortal bard, who was as good an Englishman as a poet* [London, 1803]. Beinecke Library, Yale University

62

*November the nineteenth, 1861, "The morn that I was wedded"* [London, 1886]. Beinecke Library, Yale University

## Shakefpeare's Ghoft!

OUR immortal BARD,—who was as good an ENGLISHMAN as a POET; whose Breaft glowed as much with Enthufiaftic LOVE OF HIS COUNTRY, as his Fancy with Poetic Fire,—addreffes his COUNTRYMEN in the following animated Strain:

### BRITONS!

BE STIRRING AS THE TIME; BE FIRE WITH FIRE,
Threaten the Threatener, and out-face the brow
Of bragging horror; fo fhall inferior eyes,
That borrow their behaviours from the great,
Grow great by your example, and put on
**THE DAUNTLESS SPIRIT OF RESOLUTION.**
Away; and glitter like the God of War
When he intendeth to become the field:
Shew boldnefs, and afpiring confidence.
WHAT! SHALL THEY SEEK THE LION IN HIS DEN?
AND FRIGHT HIM THERE; AND MAKE HIM TREMBLE THERE?
OH, LET IT NOT BE SAID!—Forage, and run
To meet difpleafure farther from the doors;
AND GRAPPLE WITH HIM, ERE HE COME SO NIGH.—
——Shall we, upon the footing of our Land,
Send fair-play orders, and make compromife,
Infinuation, parley, and bafe truce
To Arms Invafive? Shall a —————
————————— brave our fields,
And flafh his fpirit in a warlike foil,
Mocking the air with colours idly fpread,
**And find no check?——LET US TO ARMS!**

61

---

62

# A SHAKESPEARE CROSSWORD PUZZLE

**NOTE.**—Figures in parentheses denote the number of letters in the words required.

### ACROSS

NOTE.—Nos. 28, 29, 50, 66 and 77 across are reversed.

1 "The play's the thing,"—but which? (seven words) (3, 4, 3, 5, 2, 4, 4).
12 "The more pity that great folk should have countenance to hang themselves more than their ——" (two words) (4, 9).
15 What the smiles did in Coriolanus's cheeks (4).
18 Parolles' company and these numbered 250 each (6).
20 A duke's disguise (5).
21 "What a thing it is," said Gremio (8).
22 Siward's was knolled (5).
23 A drunken butler had a monster for his (6).
28 (Rev.) "Drink off this potion; is thy —— here? Follow my mother" (5).
29 (Rev.) A royal step-daughter (6).
30 Adriana called him a conjurer (two words) (6, 5).
33 Cold part of Shylock's home-town (3).
34 What a fool said the time was (3).
35 Valentine first refused, but then accepted this (5).
36 The ousel's is black (3).
37 By inference displayed by Desdemona on hearing Othello's life-story (7).
40 Part of the Merchant of Venice that is pleasant (4).
41 "These burrs are in my heart."
" —— them away."
"I would try, If I could cry —— and have him" (3).
42 Ophelia was not allowed to have one (7).
43 See 52 (4).
45 Pistol's broadsword (3).
46 "Molto honorato signor——Petruchio" (3).
47 Banquo told Duncan that the harvest was his this ; or, perhaps, he really said 59 (3).
49 "Accusativo ——" (three words) (4, 4, 3).
50 (Rev.) It thrice separates lovers in Shakespeare's plays (3).
51 Helena was favourably compared with them (3).
52 Caliban's had 43 eyes, and brushed dew from 8 (3).
53 Bushy and Green were not to have their souls vexed, since they were to do this to their bodies (4).
54 The Romans had these left to them (7).
56 Three-quarters of 56 down (3).
57 Dromio's 4 was due to such a cause, but he had to bear it home upon his shoulders (4).
58 Richmond was when he was a little boy (7).
59 See 47 (3).
60 Launcelot supplies an example of such a conflict (5).
62 A melancholy sort of cat, apparently (3).
64 A singular part of the Dauphin's exclamation (3).
65 One of Bottom's companions seemed to be (four words) (3, 1, 3, 4).
66 (Rev.) Isabella was told to "lay by all —— and prolixious blushes" (6).
67 Lucentio had a great desire to see it (5).
69 "Sola, sola! ——! Sola, sola!" (three words) (2, 2, 2).
73 Hamlet wanted to trip him about some 27 (5).
75 "The nimble gunner With —— now the devilish cannon touches" (8).
77 (Rev.) It rendered the good old man unseen (5).
78 "Rev.) What Bernardo's star did (6).
79 "What —— our second daughter, our dearest Regan?" (4).
82 Referred to in Othello's life-story (13).
83 Act VI. (four words) (4, 3, 9, 9).
19 Dictynna was a month old when he was born (4).
24 Wholesome berries are said to do it best in base company (5).
25 Gloucester was advised to " —— some fear," when the mare came (6).
26 These citizens of Angiers flouted two rival kings (8).
27 See 73 (3).
30 It was a wicked one to suggest that Cressida should be true (4).
31 This tree is an anagram of two salient words in Hamlet's numbers (5).
32 Hamlet wanted to know what it was (three words) (6, 2, 3).
38 "Then are our —— bodies, and our monarchs and out-stretched heroes the —— shadows" (7).
39 Claudio was going to be one of them in heaven (7).
45 Two of Childe Rowland's words (3, 3).
46 Achilles' man (8).
48 A princess said she would be this (three words) (2, 6, 5) but 54. (8)
49 Advance to the farmer who hanged himself (two words) (4, 7).
53 A shepherdess, four-fifths cupbearer (5).
54 See 48 (6).
50 "Merrily —— the stile-a." (anag.) (4).
58 The height of Bolingbroke's ambition (5).
61 Petruchio's wife called him a madbrained —— (7).
63 To be found with 17 (3).
68 Francis's slogan (4).
70 One of Doll Tearsheet's ornaments made out of a dog (4).
71 Puck's homespuns (6).
72 A fantastical Spaniard with trouble on his arm, but not much (6).
74 Did the "rude mechanicals" call her this ? (5).
76 "The ear-deafening voice o' the oracle—— to Jove's thunder" (3).
77 When the beasts Beatrice would deliver up at the gate of Hell have only one eye they turn brown (5).
80 See 14 (3).
81 There was some in Camillo's plan (3).
82 The 45 across, this and the humble-bee were at odds until the goose arrived (3).
83 "Look you, sir, he bid me —— him soundly, sir ; well, was it fit for a servant to use his master so?" (3).

### DOWN

1 What one leaves is the alternative to a festival (six words) (7, 5, 2, 4, 3, 4).
2 "When thou awak'st let love forbid Sleep his seat on thy ——" (6).
3 Cassio's trespass was described as "not almost a fault to——a private check" (5).
4 See 57 (6).
5 "Phoebus 'gins arise" (3).
6 Page a letter short (3).
7 Palpable in *Hamlet* (3).
8 See 52 (3).
9 Helen was a merry one (5).
10 Hamlet deplored a tendency to this (two words) (8, 5).
11 "What's the price of this inkle?" "One penny." " —— " (six words) (2, 3, 4, 3, 1, 12).
13 Cymbeline recognized 29 by this (4).
14 A commoner lived with this——and that was 80 (3).
16 If parti-coloured this was Jacob's (7).
17 To be found in a boiling cauldron (three words) (6, 2, 3).

NOTE.—The solution of this puzzle will be published in *The Times* of December 27.

## VIII  *Shakespeare Modernized*

By the early twentieth century, Carlyle's ability to "speak and think by" Shakespeare seems to have been a shared attribute of the educated British and American middle class. The editors of *The Times* [of London] were able to assume a familiarity with and interest in Shakespeare cultivated in school and the theater, and at least one modern reader can be found working through a Christmas Eve "Shakespeare Crossword Puzzle," though this one may have had less trouble than others completing it. The great Shakespeare bibliographer Walter Wilson Greg (fig. 63) filled in the blank spaces. "The play's the thing—but which?" reads clue 1–across; "The Life and Death of King John," wrote Greg, neatly checking off the numbers of the completed clues.

Yet even as it had become synonymous with a particular brand of English culture, Shakespeare's legacy had also become increasingly unstable. The task of remembering Shakespeare had become more and more one of authentication, in which scholars and readers struggled to identify the true text, the true source, or true author. Delia Bacon was not the last to question the ability of Shakespeare or any one individual to be responsible for the "Shakespearean" corpus. "I doubt it not," wrote Walt Whitman, in this 1891 proof copy (fig. 64) of "Shakspere-Bacon's Cipher," "then more—far more." For Whitman, as for many readers, Shakespeare seemed less playwright than cultural or natural phenomenon, found "in every noble page or text / ... In every object, mountain, tree, and star."

And even when Shakespeare's authorship was assumed, as it continued to be by the majority of readers and scholars, the question remained as to which early printed edition of Shakespeare's texts was the most definitive, best reflecting the intentions of its author. The nature of "every noble page or text" was a dominant theme of Shakespearean scholarship from the late nineteenth through the first half of the twentieth century. Greg was one of the early proponents of the "New Bibliography," a school of textual scholaship that took the material production and circulation of books as an essential frame for their study as literary texts. With its scrutiny of surviving copies, the New Bibliography promised a forensic methodology, a science of the text. It is no coincidence that, in World War II and afterwards, a generation of literary scholars came or came back to the study of Shakespeare from military service in the fields of cryptography and surveillance. Yet even these forensic approaches to Shakespeare had at their root a curious nostalgia, the belief in

63
"A Shakespeare Crossword Puzzle," completed by the scholar Walter Wilson Greg (London, n.d.). Beinecke Library, Yale University

ENGLISH 34 -- SHAKESPEARE                                    1949-50

1. Required texts for the year:

   a) Shakespeare: <u>23 Plays and the Sonnets</u>, ed. G. B. Harrison. (Those who can afford to do so will find it convenient and profitable to substitute for this the individual volumes in the Yale Shakespeare).

   b) <u>The Taming of the Shrew</u>, and probably one or two other plays not yet decided upon, in the Yale Shakespeare. (These plays are not included in the Harrison volume).

   c) <u>Hamlet</u>, <u>Othello</u>, <u>Macbeth</u>, <u>King Lear</u> and <u>Antony and Cleopatra</u>, in the Yale Shakespeare. (The detailed study of these plays requires more annotation than Mr. Harrison supplies).

   d) Brooke & Paradise, <u>English Drama, 1580-1642</u>. (The plays in this volume will be needed for outside reading and term essays).

2. Schedule of Assignments: Fall Term

   (As on attached sheet)

3. Outside reading and essay:

   An essay of about 1500 words is due on December 16th. It should develop your own ideas about some aspect of one or more plays read outside of class. The following plays are suggested:

   I. Shakespeare:
      Histories: The three parts of <u>Henry VI</u>; <u>King John</u>.
      Comedies: <u>Comedy of Errors</u>; <u>Love's Labour's Lost</u>; <u>Two Gentlemen of Verona</u>; <u>Merry Wives of Windsor</u>.

   II. Plays in Brooke & Paradise, <u>English Drama, 1580-1642</u>, especially those by Peele, Lyly, Kyd, Marlowe, Dekker, Jonson.

The following essay-topics are merely suggestive:

   1. Shakespeare and Roman comedy (Plautus and Terence).
   2. Jonson and Shakespeare as comic dramatists.
   3. Shakespeare and Lyly.
   4. Marlowe and Shakespeare's history plays.
   5. The Elizabethan ghost.
   6. Elizabethan stage clowns.
   7. Methods of characterization in Shakespeare and/or one of his contemporaries.
   8. Dramatic structure in Jonson and Shakespeare compared.
   9. The image patterns in any one Elizabethan play.
   10. The Machiavellian villain.
   11. The use of dramatic place (e.g. Belmont <u>vs</u>. Venice) as an aspect of meaning.
   12. The malcontent as a stage type.
   13. Plays within plays.

# Afterword  *Shakespeare at Yale*

In October of 1963, in a year that saw the civil rights bombings in Birmingham, Alabama, the publication of Betty Friedan's *The Feminine Mystique,* Martin Luther King's "I have a dream" speech, and the assassination of President John F. Kennedy, the Yale College graduate Edwin J. Beinecke presented the Beinecke Rare Book and Manuscript Library to Yale University on behalf of the three brothers: himself, Frederick W. Beinecke, and the late Walter Beinecke.

That same year, as he had long since done, Yale Professor of English Literature Maynard Mack gave the students of his English 34 course on Shakespeare their year-long syllabus (fig. 67). For Professor Mack's students, as for many of us, then as now, Shakespeare was a cultural institution: the subject of a college examination, of a child's performance in a high school play, of a news story on the price or theft or purchase of a first folio edition of his plays. The task of remembering Shakespeare could be both pragmatic — the need to remember enough about Shakespeare to pass or even succeed on an exam — and preparatory, a rite of cultural passage, a point to which one could later return, in remembering (as one example) the experience of taking Professor Mack's course on Shakespeare as a Yale undergraduate. Shakespeare is in this sense both Shakespeare, Elizabethan and Jacobean dramatist and actor whose works survive in a series of published poems and play texts, and "Shakespeare," the short-hand for a history of encounters between readers, editors, performers, and others with a body of dramatic and poetic work which has been taken, almost since its author's production, as a corpus of peculiar and lasting, if always changeable, interest.

In this sense, *Remembering Shakespeare* is quite literally an exhibition of Shakespeare at Yale, the title of the program of events in the spring of 2012 to which it contributes. The exhibition gathers the instances of Shakespeare's publications, of readers' and editors' encounters with Shakespeare, found in the extensive Yale collections. Shakespeare had been at Yale from its earliest days, in a nine-volume edition listed in the catalogue of the 1742 Yale College Library. When, in 1911, Alexander Smith Cochran, Yale College graduate and the founder of Yale's Elizabethan Club, sent a telegram to the Yale University Librarian stating "Confidential have secured entire collection Huth sale Shakespeares," it was because he had been inspired by a Yale Professor of English, William Lyon Phelps, to remember Shakespeare by collecting his works and those of his contemporaries.

67
Syllabus for Yale Professor Maynard Mack's English 34 course on Shakespeare, 1963. Beinecke Library, Yale University

And Phelps no doubt inspired other lovers of Shakespeare. In 1928, he invited Gene Tunney, then the heavyweight champion of the world, to lecture to his Shakespeare class, and the enthusiastic students poured from their seats at the end to have the boxer autograph their copies of Shakespeare. Other Yale faculty members were meanwhile producing some of those very editions. Just a few years earlier, Wilbur Cross, then a professor of English and shortly to become Governor of Connecticut, and Tucker Brooke began work as general editors of the Yale Shakespeare, a popular series of small, blue hardcovers of the individual plays, published first between 1917 and 1927, then revised and continually reissued well into the late 1950s. In 1955, Yale University Press also published a photographic facsimile of the Elizabethan Club's copy of the First Folio, a project overseen by Yale Professors Helge Kökeritz and Charles Prouty.

Shakespeare continues to live at and enliven Yale, though the university is just one example of the many places on this earth in which testimony is daily given to the truth of Ben Jonson's assertion that Shakespeare was "not of an age, but for all time!" We find it in the endpapers of Thomas Dowse's late sixteenth-century manuscript, with its carefully penned verses from *Lucrece*, as in the student notebooks of Yale Professor Cleanth Brooks from his Shakespeare course at Exeter College, Oxford in 1929. "Preserves chronological order—follows Holinshed very carefully," wrote Brooks about *Henry VI, part one*. Jonson's own generous act of remembering, his poem addressed "To the memory of my beloued, The Author, Mr. William Shakespeare and what he hath left us," correctly insists that Shakespeare is "aliue still," and will continue to live while his "Booke doth liue, / And we haue wits to read, and praise to giue" (fig. 68). *Remembering Shakespeare* is designed to show how vitally his book continues to live, even as it reveals that the book was never a single book, nor even in any exact sense his own. Shakespeare has been continually remembered, and continually re-imagined in the process, at once demonstrating and insuring that "what he hath left us," in Jonson's phrase, remains one of our most precious inheritances.

*68*

*Mr. William Shakespeares Comedies, Histories, & Tragedies. Published according to the True Originall Copies* (London, 1623). Beinecke Library, Yale University

# To the memory of my beloued,
## The AVTHOR
### Mr. WILLIAM SHAKESPEARE:
### AND
### what he hath left vs.

To draw no enuy (Shakespeare) on thy name,
   Am I thus ample to thy Booke, and Fame:
While I confesse thy writings to be such,
As neither Man, nor Muse, can praise too much.
'Tis true, and all mens suffrage. But these wayes
Were not the paths I meant vnto thy praise:
For seeliest Ignorance on these may light,
   Which, when it sounds at best, but eccho's right;
Or blinde Affection, which doth ne're aduance
   The truth, but gropes, and vrgeth all by chance;
Or crafty Malice, might pretend this praise,
   And thinke to ruine, where it seem'd to raise.
These are, as some infamous Baud, or whore,
Should praise a Matron. What could hurt her more?
But thou art proofe against them, and indeed
   Aboue th'ill fortune of them, or the need.
I, therefore will begin. Soule of the Age!
The applause! delight! the wonder of our Stage!
My Shakespeare, rise; I will not lodge thee by
Chaucer, or Spenser, or bid Beaumont lye
A little further, to make thee a roome:
   Thou art a Moniment, without a tombe,
And art aliue still, while thy Booke doth liue,
And we haue wits to read, and praise to giue.
That I not mixe thee so, my braine excuses;
   I meane with great, but disproportion'd Muses:
For, if I thought my iudgement were of yeeres,
I should commit thee surely with thy peeres,
And tell, how farre thou didst our Lily out-shine,
Or sporting Kid, or Marlowes mighty line.
And though thou hadst small Latine, and lesse Greeke,
From thence to honour thee, I would not seeke
For names; but call forth thund'ring Æschilus,
   Euripides, and Sophocles to vs,
Paccuuius, Accius, him of Cordoua dead,
To life againe, to heare thy Buskin tread,
And shake a Stage: Or, when thy Sockes were on,
Leaue thee alone, for the comparison

Of all, that insolent Greece, or haughtie Rome
   sent forth, or since did from their ashes come.
Triumph, my Britaine, thou hast one to showe,
   To whom all Scenes of Europe homage owe.
He was not of an age, but for all time!
   And all the Muses still were in their prime,
When like Apollo he came forth to warme
   Our eares, or like a Mercury to charme!
Nature her selfe was proud of his designes,
   And ioy'd to weare the dressing of his lines!
Which were so richly spun, and wouen so fit,
As, since, she will vouchsafe no other Wit.
The merry Greeke, tart Aristophanes,
   Neat Terence, witty Plautus, now not please;
But antiquated, and deserted lye
   As they were not of Natures family.
Yet must I not giue Nature all: Thy Art,
My gentle Shakespeare, must enioy a part.
For though the Poets matter, Nature be,
   His Art doth giue the fashion. And, that he,
Who casts to write a liuing line, must sweat,
   (such as thine are) and strike the second heat
Vpon the Muses anuile: turne the same,
   (And himselfe with it) that he thinkes to frame;
Or for the lawrell, he may gaine a scorne,
For a good Poet's made, as well as borne.
And such wert thou. Looke how the fathers face
Liues in his issue, euen so, the race
Of Shakespeares minde, and manners brightly shines
   In his well torned, and true filed lines:
In each of which, he seemes to shake a Lance,
   As brandish't at the eyes of Ignorance.
Sweet Swan of Auon! what a sight it were
To see thee in our waters yet appeare,
And make those flights vpon the bankes of Thames,
That so did take Eliza, and our Iames!
But stay, I see thee in the Hemisphere
Aduanc'd, and made a Constellation there!
Shine forth, thou Starre of Poets, and with rage,
   Or influence, chide, or cheere the drooping Stage;
Which, since thy flight fr$\bar{o}$ hence, hath mourn'd like night,
   And despaires day, but for thy Volumes light.

                       BEN: IONSON.

# *Selected Bibliography*

Of the making of books about Shakespeare there is seemingly no end, and any bibliography on the topic can be no more than partial. We have here listed the books that we found particularly useful in thinking about and putting together the exhibition, *Remembering Shakespeare,* and in writing the catalogue, hoping that this will, however inadequately, serve both to acknowledge our awareness of how dependent we have been on the learning and labors of others and function as a guide to further reading for those who have been stimulated by what they have seen.

Bate, Jonathan. *Shakespearean Constitutions: Politics, Theatre, Criticism 1730–1830.* Oxford: Oxford University Press, 1989

Blayney, Peter. *The First Folio of Shakespeare.* Washington, D.C.: Folger Shakespeare Library, 1991.

Bristol, Michael. *Shakespeare's America, America's Shakespeare.* London: Routledge, Kegan and Paul, 1990.

Brooks, Douglas. *From Playhouse to Printing House: Drama and Authorship in Early Modern England.* Cambridge: Cambridge University Press, 2000.

Chambers, E.K. *William Shakespeare: A Study of Facts and Problems.* 2 vols. Oxford: Clarendon Press, 1930.

De Grazia, Margreta. *Shakespeare Verbatim: The Reproduction of Authenticity and the 1790 Apparatus.* Oxford: Clarendon Press, 1991.

Dobson, Michael. *The Making of the National Poet: Shakespeare, Adaptation, and Authorship, 1660–1769.* Oxford: Oxford University Press, 1994.

Erne, Lukas. *Shakespeare as Literary Dramatist.* Cambridge: Cambridge University Press, 2003.

Greg, W.W. *Some Aspects and Problems of London Publishing between 1550 and 1650.* Oxford: Clarendon Press, 1956.

Hackel, Heidi Brayman. *Reading Material in Early Modern England: Print, Gender, and Literacy.* Cambridge: Cambridge University Press, 2005.

Jarvis, Simon. *Scholars and Gentlemen: Shakespearean Textual Criticism and Representations of Scholarly Labour, 1725–65.* Oxford: Clarendon Press, 1995.

Kastan, David Scott. *Shakespeare and the Book.* Cambridge: Cambridge University Press, 2001.

Lynch, Jack. *Becoming Shakespeare: The Unlikely Afterlife that Turned a Provincial Playwright into the Bard.* New York: Walker and Company, 2007.

A selection of seventeenth-century Shakespeare editions from the Beinecke Library collections

Maguire, Laurie. *Shakespeare's Suspect Texts: The "Bad Quartos" and their Contexts.* Cambridge: Cambridge University Press, 2005.

Marino, James J. *Owning Shakespeare: The King's Men and their Intellectual Property.* Philadelphia: University of Pennsylvania Press, 2011.

Marsden, Jean. *The Re-Imagined Text: Shakespeare, Adaptation, and Eighteenth-Century Literary Theory.* Lexington: University Press of Kentucky, 1995.

Massai, Sonia. *Shakespeare and the Rise of the Editor.* Cambridge: Cambridge University Press, 2007.

Masten, Jeffrey. *Textual Intercourse: Collaboration, Authorship, and Sexualities in Renaissance Drama.* Cambridge: Cambridge University Press, 1997.

Murphy, Andrew. *Shakespeare in Print: A History and Chronology of Shakespeare Publishing.* Cambridge: Cambridge University Press, 2003.

Orgel, Stephen. *Imagining Shakespeare.* Houndmills, Basingstoke, Hampshire: Palgrave Macmillan, 2003.

Roberts, Sasha. *Reading Shakespeare's Poems in Early Modern England.* Houndmills, Basingstoke, Hampshire: Palgrave Macmillan, 2003.

Shapiro, James. *Contested Will: Who Wrote Shakespeare?* New York: Simon & Shuster, 2010.

Stern, Tiffany. *Documents of Performance in Early Modern England.* Cambridge: Cambridge University Press, 2009.

Taylor, Gary. *Reinventing Shakespeare: A Cultural History from the Restoration to the Present.* New York: Weidenfeld & Nicolson, 1989.

Walsh, Marcus. *Shakespeare, Milton, and Eighteenth-Century Literary Editing: The Beginnings of Interpretive Scholarship.* Cambridge: Cambridge University Press, 1997.

Williams, George Walton. *The Craft of Printing and the Publication of Shakespeare's Works.* Washington, D.C.: Folger Shakespeare Library, 1985.

Designed and set in Albertina types by Rebecca Martz
in the Office of the Yale University Printer
Printed by GHP, West Haven, Connecticut, USA
Distributed by Yale University Press

Published in conjunction with the exhibition *Remembering Shakespeare* at
Beinecke Rare Book & Manuscript Library, Yale University, on view from
1 February through 4 June 2012. The exhibition and its catalogue contribute
to the *Shakespeare at Yale* celebration in the spring of 2012.